# The Survival of American Silent Feature Films: 1912–1929

by David Pierce

September 2013

Mr. Pierce has also created a database of location
information on the archival film holdings identified in
the course of his research.
See www.loc.gov/film.

Commissioned for and
sponsored by the National
Film Preservation Board

Council on Library and Information Resources
    and The Library of Congress
Washington, D.C.

# The National Film Preservation Board

The National Film Preservation Board was established at the Library of Congress by the National Film Preservation Act of 1988, and most recently reauthorized by the U.S. Congress in 2008. Among the provisions of the law is a mandate to "undertake studies and investigations of film preservation activities as needed, including the efficacy of new technologies, and recommend solutions to improve these practices." More information about the National Film Preservation Board can be found at http://www.loc.gov/film/.

ISBN 978-1-932326-39-0
CLIR Publication No. 158

Copublished by:

**Council on Library and Information Resources**
1707 L Street NW, Suite 650
Washington, DC 20036
Web site at http://www.clir.org

and

**The Library of Congress**
101 Independence Avenue, SE
Washington, DC 20540
Web site at http://www.loc.gov

Additional copies are available for $30 each. Orders may be placed through CLIR's Web site. This publication is also available online at no charge at http://www.clir.org/pubs/reports/pub158.

 The paper in this publication meets the minimum requirements of the American National Standard for Information Sciences—Permanence of Paper for Printed Library Materials ANSI Z39.48-1984.

*Cover*: Cameraman Rudolph Bergquist (with Mitchell camera) and director Phil Rosen (kneeling) pose during the shooting of *The White Monkey* (1925), an Arthur H. Sawyer-Barney Lubin production for First National Pictures, Inc. An incomplete copy of this film survives at the Packard Campus for Audio Visual Conservation, Library of Congress Motion Picture, Broadcasting and Recorded Sound Division.

*Photo*: The Robert S. Birchard Collection.

**Library of Congress Cataloging-in-Publication Data**

Pierce, David.
  The survival of American silent feature films, 1912-1929 / by David Pierce.
     pages cm -- (CLIR publication ; no. 158)
  "Commissioned for and sponsored by the National Film Preservation Board."
  Includes bibliographical references.
  ISBN 978-1-932326-39-0 (alk. paper)
 1. Motion picture film--Preservation--United States. 2. Silent films--United States--History and criticism. 3. Motion picture film collections--United States--Archival resources. I. Council on Library and Information Resources. II. Library of Congress. III. National Film Preservation Board (U.S.) IV. Title.

TR886.3.P54 2013
791.43--dc23

2013026170

# Contents

**Figures**

**Tables**

**Case Studies**

## About the Author

**David Pierce** is a historian and an archivist. At the British Film Institute (BFI) from 2001 to 2004, he was head of preservation of the National Film and Television Archive (NFTVA), and was appointed curator (head) of the archive in 2002. He led the NFTVA's restoration project for F. W. Murnau's *Sunrise* (1927) with the Academy Film Archive and Twentieth Century Fox.

Before his time at the BFI and since, Mr. Pierce has been active as a motion picture copyright consultant, advising motion picture producers, distributors, and exhibitors on the copyright and ownership of films and television programs. In 1999, he produced the theatrical, video, and DVD release of *Peter Pan* (1924) through Kino International, recording a new orchestral score and preparing new 35mm prints from a restored negative.

Mr. Pierce's research examines the connections between film history, copyright, distribution, exhibition, and ownership, and his articles have appeared in *American Film*, *Film Comment*, *American Cinematographer*, *Film History*, and *The Moving Image*. His seminal article, "The Legion of the Condemned: Why American Silent Films Perished," appeared in *Film History* in 1997 and was reprinted in *This Film Is Dangerous*, published in 2002 by the International Federation of Film Archives (FIAF). His reference book on the copyright status of films of the 1950s was published in 1989.

Mr. Pierce founded the Media History Digital Library, a project to digitize and provide free and open access to the printed record of the motion picture and broadcasting industries. He has worked with archives, libraries, and collectors to contribute to a comprehensive collection of research resources.

This is Mr. Pierce's fourth research report for the American archival sector. His previous research reports on digital-access and commercial-access strategies were commissioned by the Library of Congress, the UCLA Film & Television Archive, and George Eastman House.

Mr. Pierce has also curated film programs and lectured at the National Film Theatre in London and the National Gallery of Art in Washington, DC. He is a member of the editorial board of the journal of the Association of Moving Image Archivists, *The Moving Image*. He has lectured at film-preservation schools, academic conferences, and festivals. He is a graduate of the University of North Carolina, Chapel Hill, and received his MBA from George Washington University in Washington, DC.

## Acknowledgments

This project was commissioned by the Library of Congress National Film Preservation Board. I thank Alan Gevinson, Patrick Loughney, Stephen Leggett, Gregory Lukow, Mike Mashon, Donna Ross, and Rob Stone for their support and assistance.

An early version of the database associated with this report was developed over many years by Dr. Jon Mirsalis. His support of this project is appreciated. Clyde Jeavons and Roger Smither provided the opportunity to present an earlier version of this research at the 2000 International Federation of Film Archives (FIAF) Congress in London.

Numerous archivists provided information for this project: Michael Pogorzelski and Thelma Ross (Academy Film Archive); Paolo Cherchi Usai, Ed Stratmann, Caroline Yeager, and James Layton (George Eastman House); David Francis, Zoran Sinobad, James Cozart, Rosemary Hanes, Josie Walters-Johnson, Madeline Matz, David Parker, Paul Spehr, and George Willeman (Library of Congress); Ron Magliozzi, Katie Trainor, and Eileen Bowser (Museum of Modern Art); Nancy Goldman (Pacific Film Archive); Jan-Christopher Horak, Eddie Richmond, Robert Gitt, Todd Weiner, and Steven Hill (University of California, Los Angeles); Elaine Burrows, Jane Hockings, and Olwen Terris (British Film Institute/National Film and Television Archive); Ronald Grant (Cinema Museum); Vladimir Opela (Národní Filmovy Archiv); and archivists at the American Film Institute (Susan Dalton, Larry Karr, Audrey Kupferberg, and Kim Tomadjoglou).

Input from studio archivists was invaluable: Bob O'Neil (NBC Universal); Grover Crisp, Michael Friend, and Rita Belda (Sony Pictures Entertainment); Schawn Belston (20th Century Fox Film Corporation), and Ned Price (Warner Bros.).

I appreciate the support, past and present, of many archivists, scholars, and collectors, including Gordon Berkow, Robert S. Birchard, Serge Bromberg, Dan Bursik, Rusty Casselton, Herb Graff, Patricia King Hanson, Eric Hoyt, Ed Hulse, Marty Kearns, Richard Koszarski, Ted Larson, Rob McKay, Leonard Maltin, Bill O'Farrell, Richard Scheckman, Sam Sherman, Anthony Slide, Jack Theakston, Karl Thiede, and Joe Yranski. For information on 9.5mm, my thanks to contacts in Britain, including Patrick Moules and Tony Saffrey. My assessments of 9.5mm releases rely on the research of David Wyatt and Garth Pedler. My appreciation to Scott MacQueen for sharing his experience and insight.

I also thank the archivists who acquired many of the films, worked for their preservation, and made them accessible to the wider public. And special acknowledgment to Kevin Brownlow, James Card, Paul Killiam, and David Shepard.

## Foreword

On behalf of the Library of Congress, I am pleased to introduce this ground-breaking study of the survival rates of feature-length movies produced in the United States before the general advent of the sound era. Fellow historian and archivist David Pierce has taken a major step toward resolving one of the most intractable problems in the field of film preservation: determining, with certainty, how many of the films produced in the United States during the twentieth century survive today. Mr. Pierce has also created a valuable database of location information on the archival film holdings identified in the course of his research (see www.loc.gov/film/).

Enormous effort and dedication over a long period of time was required to collect and verify the information compiled in this report, involving travel to the major film archives of the world and careful research through many types of archival and business records. Movies of the silent era posed a particularly difficult challenge because those films have endured the longest period of neglect and deterioration.

Film archivists and historians have long known that a large percentage of the movies produced in the United States since the 1890s have been lost, survive only in fragmentary form, or exist in copies of such inferior image quality that it is almost impossible now to understand why they were often hailed as works of great artistic achievement by the audiences who first saw them. A great deal of anecdotal information about lost films has long been available—particularly about the films of the most famous filmmakers. But this is the first systematic survey of how many of the films produced by U.S. film studios in the early twentieth century still exist and where the surviving film elements are located in the world's leading film archives and private collections.

When Congress enacted the National Film Preservation Act of 1988, establishing the Library of Congress National Film Preservation Board and National Film Registry, I directed that one of the long-term goals of the Board would be to support archival research projects that would answer the open questions about the survival rates of American movies produced, in all major categories of production, during the nineteenth and twentieth centuries. I refer not just to the feature films, but also to the travelogues, one- and two-reel comedies, animated shorts, documentaries, newsreels, educational films, avant garde films, and other types of movies that constituted the film-going experience throughout much of the twentieth century.

Mr. Pierce's findings tell us that only 14% of the feature films produced in the United States during the period 1912–1929 survive in the format in which they were originally produced and distributed, i.e., as complete works on 35mm film. Another 11% survive in full-length foreign versions or on

film formats of lesser image quality such as 16mm and other smaller gauge formats.

The Library of Congress can now authoritatively report that the loss of American silent-era feature films constitutes an alarming and irretrievable loss to our nation's cultural record. Even if we could preserve all the silent-era films known to exist today in the U.S. and in foreign film archives—something not yet accomplished—it is certain that we and future generations have already lost 75% of the creative record from the era that brought American movies to the pinnacle of world cinematic achievement in the twentieth century.

On a positive note, the inventory database compiled by Mr. Pierce not only identifies the silent-era archival film elements that survive but also their locations in the foreign film archives that saved them from destruction. This information will make it possible to develop a nationally coordinated plan to repatriate those "lost" American movies and ensure that they are preserved before further losses occur.

Mr. Pierce's report is a model for the kind of fact-based archival research that remains to be conducted on all genres of American film beyond the scope of silent-era feature films. In addition, the same level of archival scrutiny must be applied to all historically significant audiovisual media produced since the nineteenth century, including sound recordings, radio and television broadcasts, and other new media judged to be worth saving and preserving for posterity.

Thanks to the continued support of the Congress and the great generosity of David Woodley Packard, the Library of Congress has the largest and most up-to-date facility anywhere for preserving film and audiovisual media to the highest archival standards. In cooperation with colleagues in private sector and non-profit archives, we will now be able to meet the challenge of preserving a more comprehensive archival record of American film and audiovisual creativity produced during the decades following the silent era.

—*James H. Billington*
*The Librarian of Congress*

## Executive Summary

The era of the American silent feature film lasted from 1912 until 1929. During that time, filmmakers established the language of cinema, and the motion pictures they created reached a height of artistic sophistication. These films, with their recognizable stars and high production values, spread American culture around the world. Silent feature films disappeared from sight soon after the coming of sound, and many vanished from existence.

This report focuses on those titles that have managed to survive to the present day and represents the first comprehensive survey of the survival of American silent feature films. The American Film Institute Catalog of Feature Films documents 10,919 silent feature films of American origin released through 1930. *Treasures from the Film Archives*, published by the International Federation of Film Archives (FIAF), is the primary source of information regarding silent film survival in the archival community. The FIAF information has been enhanced by information from corporations, libraries, and private collectors.

We have good documentation on what American silent feature films were produced and released. This study quantifies the "what," "where," and "why" of their survival. The survey was designed to answer five questions:

**How many films survive?**
There is no single number for existing American silent-era feature films, as the surviving copies vary in format and completeness. There are 1,575 titles (14%) surviving as the complete domestic-release version in 35mm. Another 1,174 (11%) are complete, but not the original —they are either a foreign-release version in 35mm or in a 28 or 16mm small-gauge print with less than 35mm image quality. Another 562 titles (5%) are incomplete—missing either a portion of the film or an abridged version. The remaining 70% are believed to be completely lost.

With respect to preservation, one studio stands out. Starting in the early 1960s, Metro-Goldwyn-Mayer (MGM) preserved at the corporation's expense 113 silent features produced or distributed by MGM or its predecessor companies. Starting in the 1930s, MGM also gave prints or negatives for 120 silent feature films to American archives, primarily George Eastman House. The survival rate of silent films produced by MGM after its founding in 1924 is 68%, the highest of any studio. For other companies, the proportion is much lower.

## Who holds the surviving films?

Foreign archives have proved to be an important resource for recovering important American films and filling gaps in the careers of directors and stars. The largest collection of exported American films has come from Národní Filmový Archiv in the Czech Republic. Even when films survive in the United States, the foreign versions often provide crucial missing material for restorations. Of the 3,311 American silent feature films that survive in any form, 886 were found overseas. Of these, 210 (23%) have already been repatriated to an American archive either as part of a large-scale repatriation project, such as the Gosfilmofond-Library of Congress agreement initiated in 2010, or as a one-time trade.

## How complete are the surviving films?

Only 2,749 (25%) of American silent feature films survive in complete form. Another 562 (17% of the surviving titles and 5% of total production) survive in incomplete form. Of these, at least 151 titles survive in versions that have one reel missing. Another 275 titles survive in versions that are not complete, missing two reels or more. This includes the films that survive only in 9.5mm abridgements and many of the Eastman Kodak Kodascope 16mm home library releases where footage was eliminated to reduce the running time. Finally, there are 136 confirmed fragments, where one reel or less survives. There are probably many more odd reels in collections, unidentified and uncataloged.

*Fig. 1: Survival Status of American Silent Feature Films, by Year and Format*

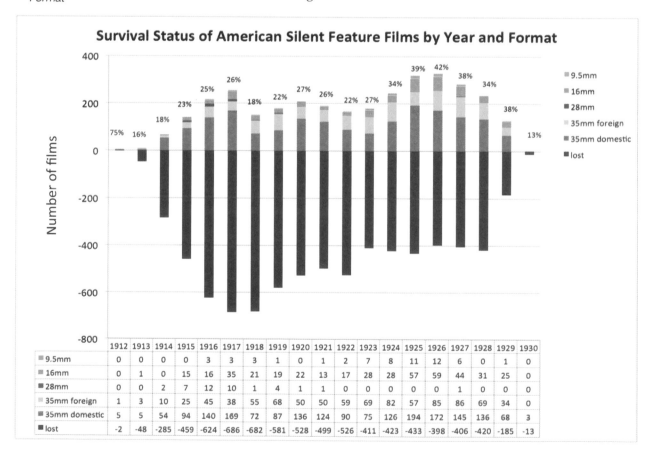

| | 1912 | 1913 | 1914 | 1915 | 1916 | 1917 | 1918 | 1919 | 1920 | 1921 | 1922 | 1923 | 1924 | 1925 | 1926 | 1927 | 1928 | 1929 | 1930 |
|---|---|---|---|---|---|---|---|---|---|---|---|---|---|---|---|---|---|---|---|
| 9.5mm | 0 | 0 | 0 | 0 | 3 | 3 | 3 | 1 | 0 | 1 | 2 | 7 | 8 | 11 | 12 | 6 | 0 | 1 | 0 |
| 16mm | 0 | 1 | 0 | 15 | 16 | 35 | 21 | 19 | 22 | 13 | 17 | 28 | 28 | 57 | 59 | 44 | 31 | 25 | 0 |
| 28mm | 0 | 0 | 2 | 7 | 12 | 10 | 1 | 4 | 1 | 1 | 0 | 0 | 0 | 0 | 0 | 1 | 0 | 0 | 0 |
| 35mm foreign | 1 | 3 | 10 | 25 | 45 | 38 | 55 | 68 | 50 | 50 | 59 | 69 | 82 | 57 | 85 | 86 | 69 | 34 | 0 |
| 35mm domestic | 5 | 5 | 54 | 94 | 140 | 169 | 72 | 87 | 136 | 124 | 90 | 75 | 126 | 194 | 172 | 145 | 136 | 68 | 3 |
| lost | -2 | -48 | -285 | -459 | -624 | -686 | -682 | -581 | -528 | -499 | -526 | -411 | -423 | -433 | -398 | -406 | -420 | -185 | -13 |

**In what format does the most complete copy survive?**
Of the 2,749 silent features that survive in complete form, 406 exist only in formats other than 35mm—small-gauge format 28mm and 16mm prints. Even more titles survive as abridged versions in 16 and 9.5mm copies. At least 72 American silent features were released in 28mm, mostly titles from the teens. Of these, 39 survive only in the 28mm format. Another 365 titles—11% of the 3,311 features that exist in some form—survive only in 16mm editions.

In Europe, the home market was dominated by the Pathé 9.5mm format. Of the 129 American silent features released in abridged versions on 9.5mm, at least 56 exist in no other form. Another 18 features survive only as paper prints submitted for copyright purposes to the Library of Congress between 1912 and 1915.

**Where was the best surviving copy found?**
Of the 3,311 feature films that survive in complete or incomplete copies, roughly 1,699 were produced by one of the major studios (or their predecessor companies). Of those, 531 titles passed directly from the studio to an archive, or were preserved by the studio. Twice as many studio titles, 1,168, have emerged from other sources.

Other films survive because the original producer kept the negative or a print, directors and stars obtained copies for their personal collections, or private collectors acquired a print.

It is impossible to determine in advance which films will stand the test of time as art, or which will prove significant as a social record. With so many gaps in the historical record, every silent film is of some value and illuminates different elements of our history.

In the 1930s, 1940s, and 1950s, when many more silent films still existed, there was never any hope to save everything; the focus was to rescue the most important films. The perennial lack of funding limited acquisitions and ensured that acquisition, cataloging, and exhibition were on a small scale until the late 1960s, when the National Endowment for the Arts began providing significant financial support.

In addition, the public domain status of some independently produced films encouraged their survival. For the most part, their producers were no longer in business and there was no one to file the copyright renewal. Once they fell into the public domain, prints were acquired by entrepreneurs who preserved them in the course of commercial exploitation.

This report concludes with six recommendations:

1. **Develop a nationally coordinated program to repatriate U.S. feature films from foreign archives.** Of the 886 American silent feature films that survive only in foreign-release versions found outside the United States, 676 (76%) have not been repatriated to an American archive; the only copies are located overseas. These titles should be reviewed and priorities set for repatriation to the United States.

2. **Collaborate with studios and rights-holders to acquire archival master film elements on unique titles.** Many of the films preserved by MGM in the 1960s still are not held by any American archive, and other companies have some unique material. A comparison of holdings between archives and studios will likely identify additional titles held only by the rights-holders.

3. **Encourage coordination among U.S. archives and collectors to identify silent films surviving only in small-gauge formats.** This project identified many films held outside of FIAF archives in nonarchival collections, including titles released on home library gauges of 28mm, 16mm, and 9.5mm. A focused outreach program would provide an opportunity to identify copies that still survive in private hands.

4. **Focus increased preservation attention on small-gauge films.** The greatest cache of unexplored surviving titles are the 432 American silent feature films that survive only in 16mm. Digital scanning would allow high-quality preservation, with restoration to follow, while the film copies can be returned to their owners.

5. **Work with other American and foreign film archives to document "unidentified" titles.** An aggressive campaign to identify unknown titles could recover important films.

6. **Encourage the exhibition and rediscovery of silent feature films among the general public and scholarly community.** The number of America's silent feature films surviving in complete 35mm copies as originally released is a disappointingly low 14% (1,575 of 10,919 features). This shortfall can be partially compensated by an increased emphasis on providing wide public access to those films that do survive for scholarship and public enjoyment. While the academic interest can be met by high-quality streaming video over the Internet, these films come to life only when they are shown to audiences. Archives can shift from a primary focus on preservation of their collections to filling the gaps in their holdings through targeted acquisition, and then emphasizing wide public availability of their holdings.

THAT THE UNITED STATES is fighting a losing battle to save its film heritage is clearest from a sobering, often-noted historical fact. Current efforts of preservationists begin from the recognition that a great percentage of American film has already been irretrievably lost—intentionally thrown away or allowed to deteriorate.

Exactly how much of America's film production has already been lost remains difficult to say. The most familiar statistic, which has attained its authority primarily through repetition, is that we have lost 50% of all titles produced before 1950.

*—Film Preservation 1993: A Study of the Current*
*State of American Film Preservation*[1]

## Introduction

The era of the American silent feature film lasted from 1912 to 1929, no longer than the period between the release of *The Godfather* (1972) and *The Godfather: Part III* (1990). During that brief span of time, filmmakers established the language of modern cinema, while the motion pictures they created reached the height of artistic sophistication. Going to the movies became the world's most successful form of popular entertainment, and these films—with their recognizable stars and high production values—spread American culture around the globe.

The silent cinema was not a primitive style of filmmaking, waiting for better technology to appear, but an alternate form of storytelling, with artistic triumphs equivalent to or greater than those of the sound films that followed. Few art forms emerged as quickly, came to an end as suddenly, or vanished more completely than the silent film. Once sound became the standard form of narrative filmmaking, with the exception of some classics available for educational screenings from the Museum of Modern Art, the masterpieces of the era largely disappeared from view.[2]

Nearly all sound films from the nitrate era of the 1930s and 1940s survive because they had commercial value for television in the 1950s and new copies were made while the negatives were still intact. Unfortunately, silent films had no such widespread commercial value—then or now. Nearly 11,000 silent feature films were

---

[1] *Film Preservation 1993: A Study of the Current State of American Film Preservation. Report of the Librarian of Congress* (Washington, DC: National Film Preservation Board of the Library of Congress, 1993), 3. Available at http://www.loc.gov/film/study.html.

[2] The Museum of Modern Art Film Library was established in 1935 "for the purpose of collecting and preserving outstanding motion pictures of all types and of making them available to colleges and museums, thus to render possible for the first time a considered study of the film as art." "The Founding of the Film Library," *Bulletin of the Museum of Modern Art* 3, no. 2 (November 1935), 2.

produced, yet today, just 80 years after the silent film era ended, only a small proportion exists to be seen. The reasons for the loss—chemical decay, fire, lack of commercial value, cost of storage—are documented elsewhere and are outside the scope of this report. Similarly outside the purview of this report is the preservation status of the films that remain.

This report covers the survival of the American silent feature film, describing its cultural significance and the statistics and impact of its loss. This statistical analysis cannot reflect the elements of entertainment value and artistic achievement that are gone forever. All the features of Buster Keaton, Charles Chaplin, and Harold Lloyd, the films Mary Pickford and Douglas Fairbanks made during the peak of their popularity in the 1920s, and the big epics, from *The Birth of a Nation* (1915) to *Wings* (1927), still exist. But for every film that survives, there are half a dozen that do not, and for every classic that is seen today, many more of equal importance at the time are now missing and presumed lost.

Many of Mary Pickford's films survive because she sent films in which she starred to the Library of Congress in 1946. "I wish to say to you," she wrote, "how happy I am that my pictures will be housed in the Library of Congress and how greatly I appreciate the honor conferred upon me by your wish to have them there."[3] Much of what survives is the result of the efforts of U.S. and international film archives curating their collections—identifying titles of interest and then actively seeking copies, building relationships with rights-holders, and occasionally acquiring entire collections.

Fig. 2: Through the Back Door (1921)–Poster. Mary Pickford worked to ensure the survival of her films, starting with a donation of films in which she starred to the Library of Congress in 1946.

More common than enthusiastic stars, however, were unsentimental businessmen, such as producer Samuel Goldwyn. In response to the Museum of Modern Art Film Library's inquiry about the destruction of sets on the backlot he had taken over from Pickford and Fairbanks, Goldwyn replied, "[You] must realize that I cannot rest on the laurels of the past and cannot release traditions instead of current pictures."[4]

The major studios were even less sentimental about their traditions, with their focus only on current releases. The exception was the active duplication program conducted by MGM under the leadership of Raymond Klune and Roger Mayer, which started around 1960. This led to the preservation of every film still surviving in the studio's vaults—films from MGM and affiliated companies. Once preserved by the studio, the remaining nitrate masters were donated to George Eastman

---

[3] Mary Pickford to Luther Evans, Librarian of Congress, October 29, 1946. Motion Picture Division Papers, Manuscript Division, Library of Congress.

[4] Samuel Goldwyn to John Abbott, Museum of Modern Art Film Library, telegram, August 18, 1938. Goldwyn file, Master collection files, Museum of Modern Art Department of Film. Thanks to Ron Magliozzi for making this material available.

House starting in 1965. The other studios merely stored what nitrate still remained in their collections, destroying copies as they started to show evidence of deterioration.

Starting in 1968, the efforts of the American Film Institute (AFI), funded by the National Endowment for the Arts, led to the placement of other studio nitrate collections with archives. The surviving Columbia Pictures and Warner Bros. silent negatives and Paramount prints came to the Library of Congress, along with the few surviving Universal silent features held by the studio. The Museum of Modern Art acquired the Fox nitrate prints, with a few titles going to other archives. Thirty years later, a discovery of additional Fox material was placed with the Academy Film Archive. The First National productions still in existence were deposited with George Eastman House and the UCLA Film & Television Archive.

Each archive has also received films from collectors, small companies, and overseas archives, thus preserving and providing access to titles that would otherwise have been lost or at least unavailable

*For every silent film that survives
there are half a dozen that do not.*

in the United States. Differences in collecting policies, personalities, parent organizations, and funding challenges for the five major U.S. archives have led to a variety of holdings that together constitute the national collection. Because some silent features are held by more than one archive it is not possible to neatly characterize which archive has the most titles.

David Woodley Packard has provided the most wide-ranging support for archival activities, first through the David and Lucile Packard Foundation and subsequently the Packard Humanities Institute (PHI). The Packard Campus for Audio Visual Conservation, designed and built by PHI for the Library of Congress, became operational in 2008 with state-of-the-art storage facilities to ensure the longevity of collections. The library's nitrate-preservation program began in 1958 and moved to an in-house preservation film laboratory in 1970. This work is now performed at the custom-built archival film laboratory at the Packard Campus. PHI also supported the development of a nitrate-storage facility for the UCLA Film & Television Archive in Santa Clarita, California, opening in 2008 as the first phase of a fully developed preservation center.

The transformation of film archiving began in the 1980s, thanks to the efforts of Sir J. Paul Getty, Jr., who provided financial support for a Conservation Centre and new nitrate vaults for the National Film and Television Archive in the United Kingdom. In the United States, additional significant funding for archive infrastructure has been contributed by Celeste Bartos, the Louis B. Mayer Foundation,

and the Academy Foundation.[5]

This report focuses on those American silent feature films that have managed to survive to the present day. It is the first comprehensive survey of the survival of American silent feature films. It provides context for both the survivors and the missing. The statistics are humbling, documenting losses that would be unimaginable for any other serious art form.

The report's significance lies not only in putting a figure to the survival rate but also in establishing a statistical foundation for the work to follow. Development of strategies to preserve and access the remnants of America's silent film heritage can now be based on solid data. The identification of gaps in holdings by American archives can encourage the repatriation of titles that exist only in overseas collections or with private companies. Even for titles that are already preserved elsewhere, domestic archives perform an important role in providing access.

For many titles, the copies released to home and school markets are now the sole surviving record of those works. Because these editions are on safety film, their acquisition and preservation had been seen as less urgent, but the prints are subject to chemical deterioration. These small-gauge editions need focused attention in cooperation with the collector community to ensure their survival, as unique copies of films become untraceable over time.[6]

Developing accurate and comprehensive lists of surviving and missing films will support the archival sector's goal to preserve America's cinema history and make it available to the public.

## The Silent Film Era Comes to an End

The first Academy Awards, cohosted by Academy President Douglas Fairbanks and Vice President William C. deMille, were presented at a dinner at the Hollywood Roosevelt Hotel on May 16, 1929. While the Oscars represented a new maturity for the industry, the first awards were also a farewell to its early years. Since the most commercially successful film of the season was not successful in the voting, the Academy board created a special award for *The Jazz Singer*. "These awards are given for work accomplished during the year 1928," deMille told the audience. "There is only one award in this whole list that has anything to do with talking pictures. It seems strange when you stop and look over the field and see how many talking pictures are being distributed today."[7]

The Academy had selected the films that its members saw as

---

[5] The Celeste Bartos Film Preservation Center of the Museum of Modern Art opened in 1996, the same year as George Eastman House's Louis B. Mayer Conservation Center. The Pickford Center for Motion Picture Study in Hollywood, home of the Academy Film Archive, opened in 2002. The Academy Foundation, the educational and cultural arm of the Academy of Motion Picture Arts and Sciences, funds the Academy Film Archive.

[6] For example, a 16mm original print of *Wild Beauty* (1927), a Universal western with Rex the Wonder Horse, not held by any archive, sold on eBay on May 13, 2011.

[7] *AMPAS Bulletin*, no. 22, (June 3, 1929): 2–3, The Academy of Motion Picture Arts and Sciences, Margaret Herrick Library Digital Collections. Available at http://digitalcollections.oscars.org.

*Fig. 3:* The Jazz Singer *(1927)–Poster. When the first Academy Awards were presented in 1929, silent film was already on the decline. A special award was created for* The Jazz Singer, *the first feature-length motion picture with synchronized dialog sequences.*

the pinnacle of their art, a seamless combination of expressive acting, expressionistic photography, the moving camera, a minimum of dialog and titles, and an unreality of time and place. This technique was being replaced by a new type of film that, at least initially, often featured stage acting, static photography, a fixed camera, and an emphasis on dialogue, sound, and space that audiences found refreshing and real. Those "talking films" managed to overtake and obliterate the silent feature so rapidly that by the date of the first Academy Awards, nearly every first-run film playing in New York City was a talkie. A month later, Douglas Fairbanks started work on his first all-talking film. The holdouts had surrendered and the sound revolution was complete.[8]

Silent films became an increasingly distant memory as the history of the first four decades of film was left behind. In 1947, to commemorate its twentieth anniversary, the Academy scheduled screenings of each year's award-winning films. After a mere two decades, five of the winners from the first year could not be shown, as "no prints are available."[9] Within another two decades, several titles that were screened in the 1947 series no longer were believed to exist, including two films starring German actor Emil Jannings: *The Way of All Flesh* (1927), featuring his Academy Award–winning performance, as well as Ernst Lubitsch's *The Patriot* (1928), the only Best Picture nominee that today is not known to exist (beyond a beautifully executed fragment).[10] The *New York Times* called the latter "a gripping piece of work" and praised Jannings' performance in "the most difficult role of his film career."[11]

Unfortunately, we have to accept the reviewer's word for it, as we cannot judge for ourselves.

---

[8] On May 16, 1929, the seven first-run Times Square theaters that changed programs weekly were running six talkies and one silent. The 12 extended-run theaters were running 10 talkies and 2 part-talkies. The first Oscars were presented for films released between August 1, 1927 and July 31, 1928, following the theatrical season. Academy Awards Database, 1927/1928. Available at http://awardsdatabase.oscars.org/ampas_awards. Starting in 1934, the awards were presented for films released in the previous calendar year.

[9] The unavailable titles were *The Last Command,* with Emil Jannings; *Sunrise; The Dove,* with Norma Talmadge; *Tempest,* with John Barrymore; and Charlie Chaplin's *The Circus.* All these films survive today, though the safety-film copy of *The Dove* has extensive nitrate decomposition copied from the deteriorating original.

[10] *The Way of All Flesh* was shown at the Academy Theatre on November 23, 1947. A three-minute excerpt from *The Way of All Flesh* was included in the Paramount short *Movie Milestones* no. 1 (1935). A seven-minute fragment from *The Patriot* is held by the Cinemateca Portuguesa - Museu do Cinema. The trailer for *The Patriot* has been preserved by the UCLA Film & Television Archive. The trailer is included in the DVD set, *More Treasures from American Film Archives, 1894–1931.*

[11] Mordaunt Hall, "The Patriot," *New York Times,* August 18, 1928. Available at http://movies.nytimes.com/movie/review?res=990CE0D61431E33ABC4052DFBE668383639 EDE.

## Overview of What Has Been Lost

*Fig. 4:* Ladies of the Mob *(1928) starring Clara Bow–Window Card. None of the four feature films that starred Clara Bow in 1928 are known to exist.*

### Evolving Views of Silent Cinema

Clara Bow was the living embodiment of the Roaring Twenties and remains as luminous a personality today as when she was one of the five top box office draws in the late 1920s. Her vitality, enthusiasm, and sensuality are undiminished, and the movies from the peak of her career—the half of her films that survive today, that is—still delight audiences. Perhaps this is not as significant a loss to humanity as the disappearance of all but 19 of the more than 90 plays by Euripides, but at least we can attribute the absence of the latter to the loss of the Ancient Library of Alexandria, not to neglect.[12]

For popular artists such as Clara Bow and her contemporaries, the view of both the industry and the public regarding their work was captured in 1934 by *Los Angeles Times* drama critic Edwin Schallert:

Making pictures is not like writing literature or composing music or painting masterpieces. The screen story is essentially a thing of today and once it has had its run, that day is finished. So far there has never been a classic film in the sense that there is a classic novel or poem or canvas or sonata. Last year's picture, however strong its appeal at the time, is a book that has gone out of circulation.[13]

Starting in the late 1940s, television led to renewed life and audiences for sound films. Meanwhile, silent films succumbed to the perils of nitrate film (fire or decay), lack of commercial value, and an extended period of disinterest by both owners and audiences.[14]

But tastes change, views of what is important evolve, and the passage of 80 years has seen an acceptance of film as one of the major new art forms of the twentieth century. With the National Film Preservation Act of 1988, the U.S. Congress established the National Film Registry in the Library of Congress to designate films that are "culturally, historically, or aesthetically significant." Librarian of Congress James H. Billington has selected 67 silent feature films for the registry (out of 600 total), and hundreds of other films of the era have been nominated by the general public.[15]

---

[12] David Stenn, *Clara Bow: Runnin' Wild* (New York: Doubleday, 1998), 157–162. Martha Nussbaum, Introduction to *The Bacchae of Euripides: A New Version* (New York: Farrar, Straus and Giroux, 1990), xxvii.

[13] Edwin Schallert, "Film Producers Shaken by Clean-Up Campaign," *Los Angeles Times*, June 10, 1934, 10.

[14] For a detailed analysis of why most silent films are lost, see David Pierce, "The Legion of the Condemned: Why American Silent Films Perished," *Film History* 9, no. 1, (1997): 5–22. Reprinted with additional information in *This Film Is Dangerous: A Celebration of Nitrate Film*, eds. Roger Smither and Catherine Surowiec (Brussels: Fédération International des Archives du Film, 2002), 144–162.

[15] Public Law 100-446: National Film Preservation Act of 1988. See http://www.loc.gov/film/filmabou.html, and Eric Schwartz, "The National Film Preservation Act of 1988: A Copyright Case Study in the Legislative Process," *Journal of the Copyright Society of the U.S.A.* 36 (January 1989): 137–159.

Two of Clara Bow's 1927 films—*It* and *Wings*—are on the registry. They are among the hundreds of silent films shown in public screenings each year. The San Francisco Silent Film Festival, which has showcased both titles, annually attracts audiences of 13,000 people over four days. But there will be no nominations or festival show-

---

*Motion pictures in the teens and twenties—before network radio, television, cell phones, and the Internet— had an influence that is hard to imagine today.*

---

ings for the film that, as Frank Thompson noted, "was an important opportunity [for Bow] to take on a starkly dramatic role after a long string of what seemed to her inconsequential comedies and racy dramas." *Ladies of the Mob* is permanently out of circulation, along with the other three features Clara Bow made in 1928—lost as assuredly as is Euripides' *The Cretans*.[16]

## The Cultural Loss

That this report focuses on cold statistics, numbers, and percentages should not blind us to the cultural and historical loss that is the greatest impact of the lost films. Motion pictures in the teens and twenties—before network radio, television, cell phones, and the Internet—had an influence that is hard to imagine today. In the mid-1920s, movie theater attendance in the United States averaged 46 million admissions per week from a population of 116 million, five times the per capita attendance rate today.[17]

"Because of the immensely seductive atmospherics of the overall experience," Scott Eyman wrote, "the silent film had an unparalleled capacity to draw an audience inside it, probably because it demanded the audience use its imagination. Viewers had to supply the voices and sound effects; in so doing they made the final creative contribution to the filmmaking process. Silent film was about more than a movie; it was about an experience."[18]

Sharing that emotional visual experience in a darkened theater with hundreds or even thousands of fellow film goers with appropriate music was a key part of the appeal. "The silent cinema was not just a roll of film in a can," wrote Richard Koszarski. "It was a complex social, aesthetic and economic fabric that brought the power of

---

[16] Frank Thompson, *Lost Films: Important Movies That Disappeared* (New York: Citadel Press, 1996), 234.

[17] Historical attendance figures from *Film Daily Yearbook of Motion Pictures* (New York: The Film Daily, 1951), 90. Modern attendance figures from "Theatrical Market Statistics 2012," Motion Picture Association of America, 6. Available at http://mpaa.org/policy/industry.

[18] Scott Eyman, *The Speed of Sound: Hollywood and the Talkie Revolution 1926–1930* (New York: Simon & Schuster, 1997), 20.

the moving image into the twentieth century."[19] Local theaters across the nation were instrumental in helping bring together their communities, while the films they exhibited captured and reflected the environment in which they were made. Surviving films permit us to see city streets where horses still outnumber the cars that were soon to displace them, and the hamlets and villages where the majority of Americans still lived. Idealized innocence and grim reality coexist in these works, along with documentary evidence of what people wore, drove, and used to outfit their houses. We can watch the early years of flight, evolving attitudes toward minorities and women, and rapid changes in public morals, the casual use of cigarettes, and trolley cars.

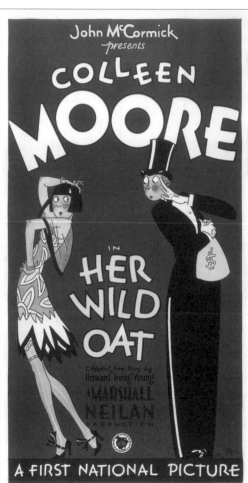

*Fig. 5:* Her Wild Oat *(1927) with Drawing by H. B. Beckhoff–Poster. The films of Colleen Moore and her flapper persona helped define the 1920s.*

Often these insights come in the smaller films, especially those dramas set in rural America where characters face the moral dilemmas that result from rapid cultural change. "Little programmers of the twenties may have relatively little to offer artistically, but they are a marvelous record of their times," William K. Everson noted. "*Our Dancing Daughters* is often referred to as the 'definitive' Jazz-Age film, but it's the Jazz Age by luxurious MGM standards. Universal's *The Mad Whirl* and lower down the scale, Pathé's *Walking Back*, actually tell us more about how the jazz-age affected the average person, while *Walking Back* in addition comments on the impact that Ernest Hemingway's writing was having, by shamelessly plagiarizing it!"[20]

With such a hold on the popular imagination, motion pictures influenced fashion and leisure, and drove the emergence of modern celebrity culture. As one example, actress Colleen Moore presented a feisty yet wholesome innocence, and her natural humor gave weight to her comedies and depth of character to her dramatic roles. Moore received more than 10,000 fan letters a week in 1926, when she was the top female star and earning $10,000 per week. Moore's breakthrough was the starring role in *Flaming Youth* (1923), where she personified a new breed of woman, the flapper. Audiences could visualize "just what a young woman who flamed and flapped really looked like," Jeanine Basinger noted. "What she looked like was Colleen Moore." Magazine artist John Held, Jr., adopted Moore's image of the chirpy and slightly muddle-headed girl for his popular cartoons of bird-brained flappers and their college boyfriends. Moore's short hair led the national craze among young women for "bobbed" hairstyles, and she further influenced fashion trends with the glamorous costumes and casual outfits she wore in her films.[21]

[19] Richard Koszarski, *An Evening's Entertainment: The Age of the Silent Feature Picture, 1915–1928* (New York: Scribner, 1990), 324.

[20] William K. Everson, "Should Everything Be Saved?," *Films in Review* 29, no. 9 (November 1978): 541–544, 563.

[21] Jeanine Basinger, *Silent Stars* (New York: Knopf, 2000), 420. The earliest film in the genre was *The Flapper* (1920), with Olive Thomas.

## The Cinematic Loss

The best-known silent film actress today may be a fictional one, Norma Desmond, the half-mad silent film diva portrayed by a genuine silent film diva in Billy Wilder's *Sunset Blvd.* (1950). Gloria Swanson gives a riveting portrayal of a long-forgotten movie goddess for whom time stands still, eternally mired in the Hollywood of 1928, subsisting on memories. As the film's doomed narrator tells us, Norma is "still waving proudly to a parade which had long since passed her by." She's a handy, if mostly inaccurate, stand-in not for the dozens of real-life actresses who had short but generally satisfying careers and went on with their lives, but for the few stars, such as Swanson, who held on to leading roles with an iron will and a tireless work ethic.[22]

Norma shutters herself in her Beverly Hills mansion, with private screenings of *Queen Kelly*, the genuine but never completed Swanson film of 1928. Norma can screen *Queen Kelly*, and so can we to this day, because Miss Swanson placed her 35mm nitrate copy, along with a few other films from her career, at George Eastman House. But no accurate assessment of the careers of the fictional Miss Desmond's real-life contemporaries is possible. There is so little to see.

The films that survive provide the breadth of silent film culture—it is still possible to view the full range of productions—but we are missing the depth, as what survives are representative examples. Scholars cannot adequately document the art and science of filmmaking without primary sources—the films themselves—thus making it challenging, if not impossible, to write in depth about many of the people and companies that produced these films.

> *Scholars cannot adequately document the art and science of filmmaking without primary sources.*

Mary Pickford owned many of her films and paid for their preservation. Of her 48 features, 8 films from the first three years of her career are lost, but the rest survive. This is a very good survival rate compared with that of many of her peers.

Pola Negri became a star in Germany, and the American period of her silent film career, from 1923 to 1928, continued her worldwide fame. Although Paramount's best directors guided her, the American films seldom matched the quality of her early films in Germany. Only 6 of her 20 starring American films survive—the Museum of Modern Art bought a print of Mauritz Stiller's *Hotel Imperial* (1927) from Paramount, as did George Eastman House with *Barbed Wire* (1927). *A Woman of the World* (1925) exists in its complete American-release version, and three others in their foreign versions. There is no

---

[22] Billy Wilder, *Sunset Boulevard* (Berkeley: University of California Press, 1999), 44.

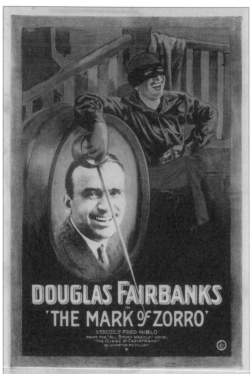

Fig. 6: The Mark of Zorro (1920)–
Poster. Douglas Fairbanks
established the popular images of
characters, including Zorrro, that
endure today.

trace of the 14 other titles.[23]

Of the 39 features that screen "vampire" Theda Bara made between 1914 and 1919, only 2 survive. Norma Talmadge was a star of "women's pictures" from 1916 through to the transition to sound, yet only 28 of her 48 starring features survive in complete form. Only 2 of the 34 films dramatic actress Pauline Frederick made before her career triumph in *Madame X* (1920) are known to exist. And the story is little better for Swanson herself, with only 15 of her 38 features surviving in complete 35mm editions.[24]

We are fortunate to have all the Douglas Fairbanks films of the 1920s that established the popular images of *Robin Hood, Zorro, The Three Musketeers,* and pirate adventures. Whether you've seen the films or not, it is Fairbanks' representations of these characters that live today, filtered and morphed over the years by Errol Flynn, Antonio Banderas, Michael York, and Johnny Depp. But we cannot follow the career of Tom Mix, who transformed the western from its Victorian theatrical melodrama roots into contemporary action narrative. Only 12 of Mix's 85 lighthearted westerns for Fox survive in their original-release versions.

If popular culture is reflected through entertainment, then where are the major blockbusters of their day? There are no known copies of *The Rough Riders* (1927), Victor Fleming's tribute to Theodore Roosevelt in the Spanish-American War. Who has seen the surprise hit of 1924, the independently produced *The Dramatic Life of Abraham Lincoln*, which codified the Lincoln myth for years to come? Aquatic ballerina Annette Kellerman was a personality of such magnitude that her life story was filmed in Technicolor as *Million Dollar Mermaid* in 1952, but today we have no trace of *A Daughter of the Gods* (1916), her "million dollar movie" filmed on location in Jamaica. Despite three reissues and Kellerman's appearance in a "tasteful" and widely discussed nude scene (both conditions that might have encouraged the film's survival), the film has vanished.

Cinematic adaptations would tell us much about the impact of popular plays and novels. Among the missing are *Main Street* (1923) and *Babbitt* (1924), based on the bestsellers by Sinclair Lewis, America's first author to win the Nobel Prize in literature; and *The Beautiful and Damned* (1922) and *The Great Gatsby* (1926), contemporary, on-the-spot adaptations of F. Scott Fitzgerald's novels. Adaptations from the stage fare no better. *Brewster's Millions* is a

[23] In 2011, the EYE Film Instituut Nederland restored Herbert Brenon's *The Spanish Dancer* (1923) from a nitrate print with Dutch titles, a nitrate print with Russian titles from the Cinémathèque Royale de Belgique, and two 16mm copies of the Kodascope abridgement. Fitzmaurice's *Bella Donna* (1923) and Ernst Lubitsch's *Forbidden Paradise* (1924) exist in their foreign-release versions. There is also a reel of outtakes from *The Woman on Trial* (1928) at the Museum of Modern Art.

[24] For details on the survival of the films of Mary Pickford, see Christel Schmidt, "Preserving Pickford: The Mary Pickford Collection and the Library of Congress," *The Moving Image* 3, no. 1 (Spring 2003): 59–81. Available at http://muse.jhu.edu/demo/the_moving_image/v003/3.1schmidt.pdf. For background information on the other female stars, see Greta de Groat's Unsung Divas of the Silent Screen website for biographies and filmographies (http://www.stanford.edu/~gdegroat).

comedy of inheritance from a 1906 play that has been filmed eight times since 1914, most recently in 1985. Clearly the story resonates across the century from our great-grandparents' time to today, but three silent versions of *Brewster's Millions*—a 1914 version with Edward Abeles, who created the role on stage; a 1921 version with Roscoe "Fatty" Arbuckle; and a 1926 version with Bebe Daniels—are as lost to history as their live theatrical counterpart.

Humorist and commentator Will Rogers was one of the most well-known and beloved American public figures of the 1920s. He starred in 16 silent features, of which only 5 survive.[25] Other popular comedians are even less well represented. One such is Raymond Griffith. Critic Walter Kerr tried to reestablish Griffith's reputation in the 1970s in his book *The Silent Clowns*. Kerr judged Griffith to be just as funny, just as talented, and just as important as Charles Chaplin, Buster Keaton, and Harold Lloyd. Nearly every one of their films survived to be seen by later generations. Kerr noted that "one reason for the neglect of Griffith's films today is that so little of his output is available. Of the 9 or 10 starring films he made between 1925 and the end of the silent period, only 3 can be seen at the moment; a fourth—even perhaps a fifth—is known to exist but is not yet in museum circulation. It is difficult to develop a new audience for a man who is more than half invisible."[26] History is told by the winners, and for film history, survival alone can be sufficient to enter the pantheon.

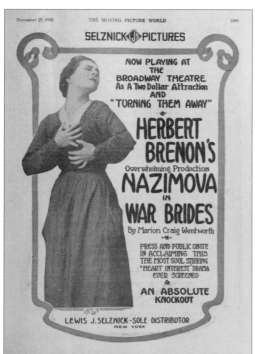

Fig. 7: War Brides *(1916)– Advertisement from* Moving Picture World, *5 Nov. 1916, p. 1099. Only reviews and advertisements survive for this World War I-era film.*

And how much better would we understand media manipulation if we could see the World War I–preparedness drama *The Battle Cry of Peace* (1915), showing an invasion of the United States by an unnamed (but Teutonic) attacker; or its complement, the pacifist *War Brides* (1916), in which widowed mothers protest the war. *Moving Picture World* acclaimed the film for reaching "a tragic height never before attained by a moving picture" with a climax "which is probably the most powerful ever seen on the screen." How clearly could be demonstrated the mercurial change in public discourse once the United States joined the war, as these films were replaced by such unsubtle propaganda films as *The Kaiser, Beast of Berlin* (1918). Extant advertising, still photos, and reviews can go only so far to communicate their effect. If we cannot view these films, we cannot accurately judge their purpose, their appeal, and their import.[27]

For many other titles, sometimes only a tantalizing fragment exists. Only a single reel survives of the only missing Greta Garbo feature, *The Divine Woman* (1928). Six of the films by director Lois Weber are missing more than half their reels. Even when a film does survive with its content intact, its experience can be substandard because of poor quality or worn elements. The visual

---

[25] Will Rogers also starred in a now-lost British production *Tiptoes* (1927), opposite Dorothy Gish.

[26] Walter Kerr, *The Silent Clowns* (New York: Knopf, 1975), 298.

[27] Edward Weitzel, "War Brides," *The Moving Picture World* (December 2, 1916): 1343–1344.

beauty of Tod Browning's *West of Zanzibar* (1928), with Lon Chaney, and John S. Robertson's *The Single Standard* (1929), with Greta Garbo, are compromised because they were copied from heavily worn prints. *Beggars of Life* (1928), with Wallace Beery and Louise Brooks, survives only in a single original 16mm copy. Beautifully staged and photographed films like Herbert Brenon's *A Kiss for Cinderella* (1925), Roland West's *The Dove* (1928), and Raoul Walsh's *The Monkey Talks* (1927) each have one entire, critical reel copied not quite in time that exists as an oily, splotchy, flickery muddle of decaying and barely legible images.

Meanwhile, innumerable low-budget westerns and program pictures exist in immaculate original prints barely used since their original release.

## Methodology, Definitions, and Scope of This Study

### Purpose of This Study

Good documentation exists on which American silent feature films were produced and released. This study quantifies the "what," "where," and "why" of their survival. This report does not examine which films have been preserved or restored, or are commercially available. The focus is strictly on what survives.

This survey was designed to quantify what still exists, whether the materials originated with an owner or elsewhere, and where the surviving copies are located—in an archive, a commercial collection, a nonarchive library, or a private collection. In some cases, based on distribution catalogs, this study considers the likelihood that copies exist with the private-collector community. Underlying the study are some key facts:

- American films were distributed worldwide; copies may be found anywhere.
- Image quality is vitally important for silent films; the original production format of 35mm for theatrical releases is the preferred format.
- Many films survive in alternate editions: abridgements, reissues (with reedited footage, rewritten titles, or added narration), foreign-release versions (with alternate footage or rewritten titles). These variants should be documented where possible.
- Hundreds of films were released for nontheatrical showing in small-gauge formats such as 16mm. Many of these films are known to survive only in prints held by private collectors; it is certain that others survive as well.

**The survey was designed to answer five questions:**
1. **How many silent feature films survive?**
2. **Who holds the surviving films?**
3. **How complete are the surviving films?**
4. **In what format does the most complete copy survive?**
5. **Where was the best surviving copy found?**

The data from the survey were then analyzed to develop
statistics that determine:
- the percentage of silent features that survive, by format and
  completeness;
- correlation of survival to year of release;
- comparisons of survival rates for films by major studios and by
  major stars and directors; and
- the sources of best surviving copies: the important role of rights-
  holders in preservation.

## Definition of an American Silent Feature Film

After the nickelodeon era, the industry began moving to longer
films, and some titles, notably *The Life of Moses* (1909), were first re-
leased as a series of shorts, with each individual reel the highlight
or "feature" of that day's program. Later, the reels were combined
and the result was distributed as a stand-alone feature. As a pro-
ducer noted in 1917, "In the majority of cases every film of more than
three thousand feet in length has recently been termed a feature" as
the term "has been applied largely to the length regardless of
merit."[28]

Program features in the teens were usually five reels, and by
the 1920s seven reels was more common. Big-budget films ran
longer to justify their higher rentals. Director Rex Ingram was
one of the few Universal staff directors in the teens who could
deliver on the promise of sensitive titles such as *The Chalice of
Sorrow* (1916) and *The Reward of the Faithless* (1917) within the
limitation of a five-reel running time. A decade later, Ingram's
production of *The Magician* (1926), the silent film that most pre-
figures the monster-horror films of the early sound period, was
a regular program release at seven reels. Ingram's epic *The Four
Horsemen of the Apocalypse* (1921), which captured the impact of
World War I on the generation that lived through it and catapult-
ed Rudolph Valentino to stardom, was 11 reels.

This report relies on the definition of a feature film devel-
oped by the editors of the American Film Institute Catalog of
Feature Films: "films of four reels or more, produced in the
United States."[29]

Toward the end of the 1920s, the definition of a silent feature
becomes more problematic. Films were released with synchro-
nized scores of music and effects, and then with talking sequences.
Films were prepared in two versions for American release: silent

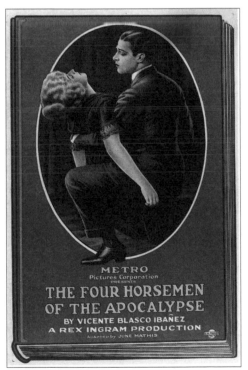

*Fig. 8:* The Four Horsemen of the
Apocalypse *(1921)–Poster. With an 11-
reel running time, the production was
among the longest silent feature films.*

---

[28] George K. Spoor, "Standardizing the Abused Word 'Feature'," *Motion Picture News*,
January 20, 1917, 382. Also see W. Stephen Bush, "The Future of the Single Reel," *The
Moving Picture World* (April 19, 1913): 256.

[29] Patricia King Hanson, ed., *The American Film Institute Catalog of Motion Pictures
Produced in the United States. F1. Feature Films, 1911–1920* (Berkeley: University of
California Press, 1988), xv. Despite the title, the catalog includes no features from 1911.

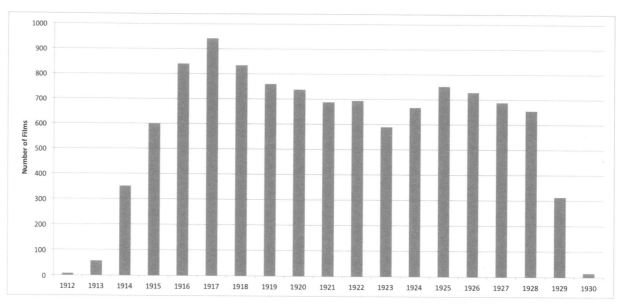

*Fig. 9: Number of U.S. Silent Feature Films Released, by Year*

(for theaters that had not yet installed sound equipment) and sound (either all-talking or part-talking with music and sound effects). A separate, nondialog edition was prepared for foreign markets, either mute or with a soundtrack of music and effects. This study includes films with recorded scores, talking sequences, or both. Titles released in both all-talking and silent versions are excluded.[30]

## Historical Period of Study

The list of silent feature films referenced in this study is derived from the AFI Catalog of Feature Films, which documents 10,919 feature films of American origin released between 1912 and 1930.[31] The range of years and the number of films released per year are shown in Figure 9.

The era of the teens is arguably the period of American cinema with the most diversity of creative technique and certainly the period in which the aesthetics of filmmaking underwent major evolution. It is the period in which the feature film was born, matured, and flowered. The absence of the majority of the works from these years has

[30] The part-talking *The Jazz Singer* and *Lonesome* meet the qualifications. Not included are *Welcome Danger* (1929), with Harold Lloyd; William Wyler's *Hell's Heroes* (1930); and *Coquette* (1929), with Mary Pickford—even though these films exist in two distinct editions, as all-talking films and as silent films. To include these titles would skew the statistics by also adding hundreds of silent versions of all-talking films released in 1929, 1930, and 1931. Few of the silent versions of these later films survive, and most, such as the silent edition of *Dracula* (1931), were mute versions of the talkie, with title cards inserted to cover the spoken dialogue, rather than separately staged and photographed silent films.

[31] The twenties are covered in Kenneth W. Munden, ed., *The American Film Institute Catalog of Motion Pictures Produced in the United States. F2. Feature films, 1921–1930* (New York: R.R. Bowker, 1971). The combined catalogs are available at http://www.afi.com/members/catalog. The listing concludes with 1930, the year of the final major studio silent releases. This excludes at least eight films from the 1930s released with music scores but no narration. These were mostly travelogues, with the notable exceptions of Charlie Chaplin's *City Lights* (1931) and *Modern Times* (1936).

skewed our historical perspective. We know well the contributions of men like D. W. Griffith, Cecil B. DeMille, and Thomas H. Ince. Less well acknowledged, if at all, are the earliest features by women film-makers. Three examples, all of which survive, are *Cleopatra* (1912), produced by actress Helen Gardner; *Eighty Million Women Want?* (1913), a political drama with a cameo appearance by British suffrag-ette Emmeline Pankhurst; and *From the Manger to the Cross* (1913), filmed on location in the Middle East with a scenario by actress and screenwriter Gene Gauntier.

The enormous, unexpected success of *The Birth of a Nation* (1915) contributed to a rush of investment in the production of longer films, with the number of releases peaking in 1917 at nearly 1,000 features. This increase in production led to an oversupply of product, and the resulting reduction in rental prices fed the growing numbers of the-aters and the rapid turnover of programs. Many small-town theaters presented a program of a feature and shorts on a bill that changed each day. This booking practice had an inevitable effect upon quality, as Universal cofounder Pat Powers noted in a letter in 1917:

> The number of pictures required by the various exhibitors, so that they will not be compelled to run the same picture the second time, no matter how good it might be, forces a great deal of stuff on the market which is not interesting or entertaining. ... The lack of the proper story has forced the picture producer to tie to the star, with the result that, the star, being exploited in this manner, naturally walks away with the profits. But, as stated, I have come to the conclusion that all things adjust themselves in time, and I presume the moving picture business will be no exception.[32]

One impact of that adjustment was that "film companies, which had been founded in virtually every state of the Union, from Maine to Florida, from Ithaca to Oregon, gravitated slowly but surely to Los Angeles," Jan-Christopher Horak wrote. "In Hollywood film producers increasingly financed their operations through loans from distributors and/or the owners of massive chains of movie theaters, forcing film producers to relinquish some of their independence."[33] Film production and theater ownership consolidated in an oligopoly of a small number of large companies, which could then reduce out-put and charge higher prices on fewer, more profitable, films.

The 1921–22 national recession caused the bankruptcy of many undercapitalized firms, and output fell again. Production hit bottom in 1923, with fewer than 600 features, then gradually rose with the growth of Hollywood's Poverty Row, the figurative home of very low-budget producers. The large companies tended to make polished films with budgets ranging between $50,000 and

---

[32] P. A. Powers to H. R. Wright, February 1, 1917. Box 13, Harry and Roy Aitken Papers, Wisconsin Historical Society Archives. Thanks to Eric Hoyt for sharing his research in this collection.

[33] Jan-Christopher Horak, "Good Morning, Babylon: Maurice Tourneur's Battle Against the Studio System," *Image* 31, no. 2 (September 1988): 1. Available at http://image.eastmanhouse.org/files/GEH_1988_31_02.pdf.

$250,000; in 1926, Fox produced 47 features. The low-budget Buck Jones westerns cost $75,000 each; almost everything else was at or under $200,000, and their one special—John Ford's *Three Bad Men*—had a production cost of $497,928. The Poverty Row contingent specialized in westerns and melodramas intended for rural and small-town theaters, shot in five days or less on a shoestring. "One gentleman produced thirty-six full-length photodramas on the Row in a period of three years," the *Saturday Evening Post* reported, "his cheapest costing $3,800 and his most expensive $12,000 … wherein the director smashed up three secondhand planes and had to pay for them."[34]

The silent era came to an abrupt end with the transition to sound in the late 1920s. The end was near when *The Jazz Singer* premiered on October 6, 1927. It is instructive to see how the largest studio, MGM, dealt with the transition. MGM's silent feature *White Shadows in the South Seas*, filmed under extraordinary circumstances on location, was outfitted with the studio's first musical soundtrack

*Fig. 10:* Three Bad Men *(1926)–Lobby Card. With a production cost of nearly $500,000,* Three Bad Men *was among the most expensive silent films made.*

and released in the summer of 1928 as its first sound release. As *White Shadows* went into wide release in November, the studio's first part-talkie, the gangster drama *Alias Jimmy Valentine,* opened in New York. In May 1929, MGM's final film without a soundtrack opened. By October, *The Mysterious Island* (a lumbering, troubled investment that had been in production for three years under as many directors) had a lone talking sequence grafted onto it, permitting it to be advertised as a "part-talkie." One month later, MGM outfitted the last of its nondialog releases, *The Kiss,* with Greta Garbo, with a recorded-music score. In February 1930, *Anna Christie* with Garbo opened with an advertising campaign declaring, "Garbo Talks!," and she did, in both English and German versions. In less than two years, American silent films had moved from first-run, internationally friendly, to obsolete.

## Sources of Data

*Treasures from the Film Archives*, published by the FIAF, is the primary source of information regarding silent film survival in the archival community. FIAF member archives from every country contributed holdings information on the silent features and short films in their collections. Some archives acknowledge only that a title is held in their collection, while others provide details such as format (35mm, 16mm), and whether their holdings are nitrate or safety, print or negative, and complete or incomplete. Information on American silent features was received for *Treasures from the Film Archives* from 37 of FIAF's more than 150 members, including most of the archives known to have large collections of American films. (See the

---

[34] Frank Condon, "Poverty Row," *Saturday Evening Post,* August 25, 1934, 30.

Appendix for a list of participating archives).[35]

The FIAF information has been supplemented by extensive discussions with each American archive, a limited amount of information from corporations and library collections that possess materials, and information on the holdings of private collectors in the United States and Great Britain. Major additions include the David Bradley collection at the Lilly Library at Indiana University, the Blackhawk collection held at the Academy Film Archive, and the MGM film library, now part of Turner Entertainment at Warner Bros., with the surviving nitrate film elements held at the George Eastman House.

## Findings

### Most American Silent Feature Films Are Lost

There is seemingly no rhyme or reason why certain films survived, as neither quality nor critical reputation determined their fates. The driving forces that retained and disposed of these films were typical of the industry that made them—economic, not artistic. With these factors working against them, plus the vulnerability of nitrate film stock to fire and deterioration, it is remarkable that *any* silent films survive.

> Only 14% of American silent feature films (1,575 of 10,919 titles) survive as originally released in complete 35mm copies. Another 11% (1,174) also survive in complete form, but in less-than-ideal editions—foreign-release versions or small-gauge formats such as 16mm.

Our American silent film heritage was saved from the brink of extinction by film archives that acquired key studio releases while the negatives still existed and small companies run by film enthusiasts willing to invest in abandoned films whose copyrights had lapsed and could legally be distributed. Film collectors rescued prints, orphan or otherwise, because it was the only way to see the films that interested them.

> Most of the prints acquired from the major studios by the Museum of Modern Art and George Eastman House, from the 1930s through the 1950s, became the only copies in existence by the mid-1960s, as the studios' older copies deteriorated in their vaults.

---

[35] *Treasures of the Film Archives* describes the holdings of FIAF member archives for films of the silent era. This includes all countries, fiction and nonfiction, features, and shorts. In general, it is an indication of holdings, not whether a copy is available for research viewing or loan. For information on the commercial edition, licensed by Chadwyck-Healey, see http://fiaf.chadwyck.com/marketing/about.jsp. For the CD-ROM version, available for sale to individuals, see http://www.fiafnet.org/uk/publications/fdbo_content.html.

Only one owner, MGM, saw long-term value in its entire library. While that studio certainly had losses resulting from decomposing nitrate, MGM never participated in the wholesale destruction of material dictated, for example, by the new management of Universal-International that caused the willful disposal of nearly its entire remaining silent catalog in 1948. Nor had MGM experienced the near-total loss of its silent and early sound negatives by fire as experienced by Warner Bros. and Twentieth Century-Fox in the 1930s.

> **MGM preserved, at the corporation's expense, 113 silent features produced or distributed by MGM and its predecessor companies Metro Pictures, Goldwyn Pictures, and Louis B. Mayer Productions. Starting in the 1930s, MGM also gave prints or negatives for 120 silent feature films to various American archives, primarily George Eastman House.**

Beginning in the 1960s, under the leadership of studio operations manager Raymond Klune and his successor, Roger Mayer, MGM invested in the preservation of those titles still in existence. In his acceptance speech for the Jean Hersholt Humanitarian Award at the Academy Awards in 2005, Roger Mayer noted that "as for film preservation, I must give credit to the six board chairmen and seven production heads who either backed our endeavors or weren't quite sure what we were doing so let it happen anyway. And then came Ted Turner and his cohorts in Atlanta, who understood the importance of all this and kept it going when funds were pretty short."[36]

Today, the silent film output of the MGM studio (1924–1929) is the most comprehensive collection of its pre-sound output of any Hollywood producer. Other owners were, at best, indifferent. If additional major studio films survive, it is because of the preservation efforts of archives working in cooperation with rights-holders and private collectors.

> **The survival rate of silent films produced by MGM is 68%, by far the highest of any studio.**

Few silent feature films survive in complete, pristine condition. About 175 titles, including titles donated to archives by MGM, Paramount, RKO, Universal, and Warner Bros., survive at least partially in original nitrate camera negative (although these are seldom the films enthusiasts would most like to see).

---

[36] Roger Mayer, acceptance speech for the Jean Hersholt Humanitarian Award, 2004 (77th) Academy Awards, Kodak Theatre, February 27, 2005. Available at http://www.oscars.org/research-preservation/resources-databases.

Another 5% of American silent feature films (562 of 10,919 titles) survive in incomplete form, missing at least a reel of the original footage, in formats ranging from 35mm down to abridged 9.5mm home library prints. Many important titles are incomplete.

The major studios generally stored negatives on the East Coast, where the release prints were manufactured. Prints were more likely to survive on the West Coast, where studio library prints were kept for screenings or viewing for potential remake. Most existing films, including studio titles, survived only as unique nitrate prints, sometimes heavily worn and often incomplete. It is rare to find major studio films in private collections because the studios kept tight control of their prints.

Almost all titles found overseas are prints, along with a few foreign-release negatives found abandoned in film labs.

Small producers held their negatives, often in buildings they owned or in other low-cost storage. D. W. Griffith, Douglas Fairbanks, William S. Hart, and the corporate successors to Biograph and Edison donated their entire film libraries to the Museum of Modern Art between 1938 and 1941. In several cases, negatives and prints were already in an advanced state of decay upon receipt. Later, large-scale donations, this time to the AFI Collection at the Library of Congress, included the Thomas H. Ince films in 1971 from the producer's heirs, and the Marion Davies/Cosmopolitan Productions preprint material in 1972 from the actress's estate.

*Fig. 11:* The Patsy *(1928)–Lobby Card. The estate of actress and producer Marion Davies donated prints and negatives of her films to the Library of Congress in 1972.*

| Definition | Examples from the film career of Lon Chaney | |
|---|---|---|
| COMPLETE<br>The film is complete or missing less than one reel | | Released by the Universal Show-at-Home Library |
| ONE REEL MISSING<br>Missing exactly one reel | | Missing reel four |
| NOT COMPLETE<br>Missing two or more reels | | Cut to 35 minutes for the French 9.5mm home movie market |
| FRAGMENT<br>One reel or less survives | | Five minutes of the film survive |
| LOST<br>No copies are known to survive | | Lost |

Fig. 12: Definitions and Categories of Film Completeness, with Examples

## Not All Surviving Films Are Complete

Finding copies of missing films has always been a race against time. Films are lost to fires nearly every year, and to decomposition every day. For the purposes of this report, "completeness" is divided into five categories, depending on how much of a film survives, as detailed in Figure 12.

Of the 3,311 American silent feature films released between 1912 and 1930 that survive in some form, 25% (2,749 out of 10,919 titles) survive in *complete* form. For the purposes of this study, if a film is missing less than a reel of footage, it counts as complete. Many films have short sections missing (most frequently at the beginning and end of reels, or censor cuts). Without a synchronized soundtrack to make those jump cuts obvious, these gaps often have minimal effect upon the film's narrative logic and entertainment value. In addition, some of the biggest studio productions were initially released as reserved-seat road show attractions, followed by a shortened version in a general release a year later. Many of these titles survive only in their general-release versions, with *The Hunchback of Notre Dame* (1923) reduced from 12 reels to 10, and *The Trail of '98* (1928), MGM's epic of the Klondike gold rush, 40 minutes shorter than the 127-minute premiere. Rather than untangle this web, this report considers any surviving copy that matches an original-release edition to be complete.

Another 562 (17% of the surviving titles and 5% of total production) of the silent feature films survive in incomplete form. At least 151 titles survive in versions that have one reel missing. The loss of a reel does not generally affect the entertainment value, and these films are still shown to the public and released on DVD. Another 275 titles survive in versions that are not complete (i.e., missing two or more reels). This includes the films that survive only in 9.5mm abridgements and many of the Kodascope home library releases where footage was eliminated to reduce the running time. Finally, there are 136 confirmed fragments for which one reel or less survives. There are probably many more odd reels in collections, unidentified and uncataloged.[37]

Archives have generally retained incomplete copies and removed decomposition from each roll upon inspection, saving the remainder. A commercial owner was more likely to junk any title that was incomplete as having no commercial value (again, the exception to the rule was MGM, which preserved at least 11 incomplete features).

Even an incomplete surviving copy is far from worthless. Time and again, the preservation of incomplete copies and fragments has been the prelude to restoration, as an incomplete local copy has frequently been augmented by footage from second and third copies discovered elsewhere.

---

[37] Information on completeness is generally accurate for American archives and some foreign holdings. Unless I had evidence otherwise, all foreign holdings were assumed to be complete. The practice varies across archives; some institutions submit all titles, including those they hold only in fragments, while others provide information only when they hold complete prints. Some of the films that are not complete (i.e., missing one reel but satisfactory for commercial release) include *Sadie Thompson* (1928), *Laugh, Clown, Laugh* (1928), and *Bardelys the Magnificent* (1926).

Figure 13 illustrates that one-quarter of the surveyed titles are essentially complete, with another 5% surviving in varying degrees of completeness.

## Films Survive in Different Formats

### The Preferred Edition is the 35mm Domestic-Release Version

Of the 2,749 films that survive in complete form, about 2,343 exist in the 35mm format. This makes it possible to view them in nearly their original pictorial quality. During the silent era, every release print had remarkable sharpness, definition, and shadow detail because each print was made directly from the first-generation camera negative.

Those 2,343 35mm titles are of two types: 67% survive in their original domestic-release version as shown to American audiences, and 33% (768) survive only in foreign-release editions. By the mid-teens, most silent features were photographed twice, so that a second negative could be sent to Europe to manufacture prints locally for the foreign markets. This second negative roughly matched the domestic negative and was usually assembled from a combination of footage taken by a second camera and of alternate takes. Where both versions survive and can be compared, the foreign version is always the lesser version—not an exact representation of the original, but a close replica, often with different shots, performances, and editing.

When considering authenticity, these foreign-release versions of American silent features should be treated as *a* text, not *the* text. The first published version of Shakespeare's *Hamlet* was a quarto, a pirated printing, probably transcribed from memory by an actor. The dialogue, "To be, or not be, I there's the point," captured the content, but not the art and grace, of the authorized text we have come to know. As Stuart Kelly noted in his survey of lost books, "Slips

*Fig. 13: American Silent Feature Film Survival, by Categories of Completeness*

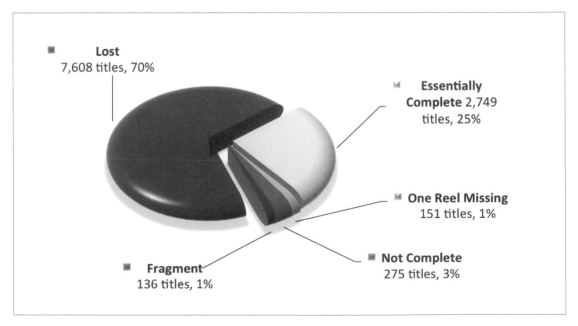

and mishearing, presumptions and anticipations typify the hastily assembled bad quarto," and the introduction to the authorized folio edition, published after Shakespeare's death, warned against "copies, maimed and deformed by frauds and stealths of injurious impostors."[38]

---

*Most existing films, including studio titles,*
*survived only as unique nitrate prints, sometimes*
*heavily worn and often incomplete.*

---

*Hamlet* was subsequently published in the first folio of Shakespeare's works, allowing comparison of the authentic text to the lesser copy. Similar analysis is essential when viewing films that survive in multiple versions. For example, the American- and European-release versions of Paul Leni's *The Cat and the Canary* (1927) reveal major differences. All but three shots in the film showed different performances, with the shots in the European print often appearing to be rehearsal footage. The two versions represent, Christopher Bird wrote, "the difference between a smooth, flowing, impeccably paced film (the American version), and a flabby, jarring film (the European version)."[39]

Those films that survive as both foreign-release versions in 35mm and American-release editions in 16mm present a difficult choice between the superior image quality of 35mm and the authenticity of the 16mm copy for shot choice, editing, and titles. In trying to establish a hierarchy of authenticity for silent films, many archivists believe that the superior image quality of 35mm for public performance—even of the foreign version—is preferable to a 16mm copy of the American release. For historical analysis, the domestic-release version represents the most accurate record of the intent of the filmmakers and what American audiences viewed at the time. Often the two are used in tandem, with the 16mm copy used as a guide to restoration for the 35mm foreign-release version.

Categorizing the various surviving versions has required drawing fine distinctions to determine the most appropriate category for each film. This report considers the best edition to be a 35mm copy of the original American-release edition. The foreign-release version in 35mm is considered next, followed by a small-gauge print of the original American-release version. As expected, the larger image size is preferred over small-gauge prints, with copies of the

---

[38] Stuart Kelly, *Book of Lost Books: An Incomplete History of All the Great Books You'll Never Read* (New York: Random House, 2006), 141.

[39] Christopher Bird, "*'Europe Ain't Gonna See This Scene!': Working with Variant Versions* in Photoplay *Productions' Restoration of* The Cat and the Canary," *The Moving Image* 9, no. 2 (Fall 2009): 149–163. *Photoplay* had access to two prints, each from different sources of the domestic and foreign versions of the film, so the flaws could be identified to the release version, rather than to the idiosyncrasies of a particular print.

| File Format | Definitions | Examples | |
|---|---|---|---|
| | **35mm domestic release version** | | Most surviving MGM films exist in their original release version. |
| | **35mm foreign release version ("B" negative)** | | A few MGM films survive only in copies distributed in the United Kingdom in partnership with exhibitor William Jury. |
| | **28mm Pathéscope format** | | Douglas Fairbanks starred in a series of popular light comedies. *The Americano* (1917) survives only in 28mm. |
| | **16mm** | | *Manhandled* (1924) exists only in a 16mm Kodascope home library print, cut from seven to five reels. |
| | **9.5mm** | | *Station Content* (1918) with Gloria Swanson survives only in a 9.5mm abridgement. |
| | **8mm** | | *Partners Again* (1926) survives only in 8mm. |

*Fig. 14: Guide to Major Film Distribution Formats*

original-release version in various small-gauge widths of 28mm, 16mm, 9.5mm, and 8mm following. Images of each format are presented with examples in Figure 14.

## Many Films Survive Only in Small-Gauge Formats

Of the 2,749 silent features that survive in complete form, 406 exist only in formats other than 35mm—small-gauge format 28mm and 16mm prints. Even more titles survive as abridged versions in 16 and 9.5mm copies. After films had exhausted their theatrical value, many titles were offered in these smaller-size film formats for nontheatrical showings in schools, institutions, and homes.

Schools were seldom equipped to show nitrate prints. Although some educational titles were released on 35mm diacetate (nonflammable) film stock, the risk of mistakenly showing 35mm nitrate film was too great. Because a nitrate film fire could spread from the projector to an auditorium in seconds, fire laws required an enclosed, fireproof projection booth and a trained projectionist, which meant that most institutions showed no films at all. The 28mm format, called "the safety standard," proved to be no cheaper than 35mm, but it was sufficiently incompatible to eliminate the possibility of a projectionist threading up a nitrate print by mistake. Introduced in 1923, 16mm successfully addressed the shortcomings of the 28mm format. Another home format, 9.5mm, was introduced in 1922, followed by 8mm in 1932. The later formats were less expensive and cheaper to ship, and gave a satisfactory image on a small screen.

**28mm**. At least 72 American silent features were released in 28mm, mostly titles from the teens. Of these, 39 survive only in the 28mm format. Another 13 titles were released in these editions, but 28mm prints have yet to be located (one exists in a 16mm Kodascope edition), so they must be considered lost. Another 21 titles also survive in 35mm.[40]

*Fig. 15: Watching Small-Gauge Films at Home, from* Descriptive Catalogue of Kodascope Library 16mm Motion Pictures: Sixth Edition *(1936). Many silent films survive only in small-gauge editions created for showing in homes and schools.*

The 28mm prints that do survive fill important gaps in the nitrate record. One of the most revered pictorialists of the period is director Maurice Tourneur, who came to the United States from France in 1914 and worked at studios in Fort Lee, New Jersey. Tourneur was renowned for the visual qualities of his films—the sets or landscape carefully chosen, the camera in the ideal place, and the performances relaxed and natural. In 1916, *Photoplay* magazine wrote "in the all too short list of great directors that the wonderful new art has produced, the name of Maurice Tourneur must be given a distinctive place." But we can confirm this today only

---

[40] There were two slightly different 28mm formats, but they are treated as one for the purposes of this report.

The Original
16 mm. Film Library

Largest in the World
Sound and Silent Films

*World-Wide Organization*
*Thirteen Years Experience.*

Exclusive Authorized Distributors of:
Essanay & Mutual Chaplins, King of Kings,
Oliver Twist, Mickey Mouse and Silly Symphony
Sound Cartoons and Many Other of the
Choicest Pictures of Major Distributors

Travel, Natural History, Scientific Subjects, Sports,
Animated Cartoons, Comedies, Dramas

Nearly 25,000 Reels

We mail on request:—
200 PAGE SILENT FILM CATALOGUE
76 PAGE SOUND-ON-FILM CATALOGUE

**KODASCOPE LIBRARIES, INC**

33 WEST 42nd STREET   NEW YORK, N. Y.
and 18 other leading cities of the U.S.A. and Canada

Subsidiary of

Eastman Kodak Company

ROCHESTER, N. Y.

*Fig. 16: Advertisement for Kodascope Libraries, from* 1000 and One: The Blue Book of Non-Theatrical Films, *1936. Eastman Kodak established the 16mm format in 1923 and offered hundreds of films for rental through their Kodascope Libraries subsidiary.*

because three of his first seven American films survive in 28mm prints: *The Wishing Ring* (1914), *The Cub,* and *Trilby* (both 1915).[41]

Douglas Fairbanks was a prolific actor in the teens. Richard Corliss called Fairbanks' screen character "a movie vision of young America on the ascendance in the decade after World War I," characterizing him as "half-Tom Sawyer, half-Theodore Roosevelt." Seven of his films for Triangle were released in 28mm. Five of those delightful light comedies survive only in those 28mm copies: *The Lamb (1915), His Picture in the Papers, Reggie Mixes In, American Aristocracy* (all 1916), and *The Americano* (1917).[42]

While the popularity of the format peaked in the late teens, 28mm releases continued through the silent era. The last known release in that format is the low-budget Jacqueline Logan romance for Tiffany, *One Hour of Love* (1927), directed by Robert Florey.

**16mm**. At least 365 titles—11% of the 3,311 features that exist in some form—survive only in 16mm editions. Eastman Kodak introduced this popular format in 1923 for home and institutional users, supported by a library of entertainment and educational films available for rental. While the 28mm libraries were largely limited to films from companies that had gone out of business, Kodak ensured that most of the major producers participated. The Kodascope rental libraries offered 134 American features including 16mm versions of the most popular 28mm titles. The majority of Kodascope offerings were from the mid-1920s and from major studios: DeMille, First National, Fox, Paramount, and Warner Bros., the companies that later became RKO and Columbia, as well as smaller producers and independents.[43]

Of the 134 American features released by Kodascope, 30 also survive in 35mm domestic- or foreign-release versions and 9 were released in 28mm. But for 77 titles, these Kodascope prints represent the only known surviving copies. Another 15 titles released by Kodascope and not yet held by archives may survive in private collections.

Many Kodascope titles were professionally abridged, often from seven reels to five, to reduce the running time to about an hour. Printed from 35mm duplicating negatives, these films had relatively

---

[41] "Tourneur—Of Paris and Fort Lee, His Methods and His Artistic History," *Photoplay,* January 1916, 139–140. Reprinted in Richard Koszarski, *Fort Lee: The Film Town* (Rome: John Libbey Publishing, 2004), 171.

[42] Richard Corliss, "The King of Hollywood," *Time,* June 17, 1996. Available at http:// www.time.com/time/magazine/article/0,9171,984717,00.html. The two Fairbanks titles released in 28mm that also survive in 35mm are *Flirting with Fate* (1915) and *The Matrimaniac* (1916).

[43] David Pierce, "Silent Movies and the Kodascope Libraries," *American Cinematographer,* January 1989, 36–40. MGM and United Artists were the only major companies that did not provide at least a few titles.

good image quality. From the 1920s through the 1960s, these were the silent features most widely available to schools and libraries. Films surviving only in Kodascope editions include films with strong female characters, including Allan Dwan's *Manhandled* (1924), with Gloria Swanson as a shop girl with aspirations; *The Forbidden City* (1918), with Norma Talmadge as a Chinese-American torn between both cultures; and *Ella Cinders* (1926), with Colleen Moore as a small-town Cinderella who wins a chance to go to Hollywood.

Kodascope also had its share of action titles, ranging from Paramount's big-budget historical western *The Covered Wagon* (1923) and its follow-up *The Pony Express* (1925), to the austere *The Return of Draw Egan* (1916), with William S. Hart. Five titles starred the ever-popular Rin-Tin-Tin, including one of his best, *The Lighthouse by the Sea* (1924), with the famous German Shepherd coming to the rescue of a blind, aging lighthouse keeper. A perennial favorite was a five-reel condensation of First National's *The Lost World* (1925), an adventure film about explorers who visit a land of dinosaurs; it was the only edition available until a late-1990s restoration.

Following the successful launch of 16mm, several U.S. studios began selling their titles directly to camera stores and rental libraries across the country. Columbia Pictures offered many, including several directed by Frank Capra. Among these were his first at the studio, the charming *That Certain Thing* (1928), and *The Power of the Press* (1928), with Douglas Fairbanks, Jr. The estate of producer Thomas

## CASE STUDY
## *A Lost Classic Once Released in 16mm*

We *Americans* (1928) is a drama of immigration and ethnic assimilation, a special interest of Universal's German immigrant founder Carl Laemmle. In the film, director Edward Sloman tells the interwoven story of three families—Russian, German, and Italian—who come to America at the turn of the century.

"It is a tragedy that Universal allowed their silent films to rot or burn," wrote Kevin Brownlow. "*We Americans* would today be of immense historical importance." The studio had the full cooperation of the government, so the production company filmed on location on a ship in quarantine at the Statue of Liberty and documented the immigration process at Ellis Island.[i]

When Universal destroyed its remaining silent negatives in 1948, 17 titles were held back, either because of their importance to studio history or potential remake value. *We Americans* was one of the titles given a pardon from execution, but unfortunately the negative deteriorated before the studio gave its remaining silent nitrate film to the Library of Congress more than 20 years later.[ii]

*Photoplay* highlighted one scene, a war sequence that "gives a motive for the high spot of the picture. Mrs. Levine, going to night school, has mastered enough English to read to the class the Gettysburg Address. As she reads the closing words ... 'and they have not died in vain,' she is handed the telegram carrying the news of her son's death overseas. A very tense moment beautifully handled."[iii]

---

[i] Kevin Brownlow, *Behind the Mask of Innocence: Sex, Violence, Crime: Films of Social Conscience in the Silent Era* (New York: Knopf, 1990), 416.

[ii] F. T. Murray, Manager, Branch Operations, Universal Film Exchanges, Inc., to I. Stolzer, Bound Brook, NJ, April 27, 1948. Memo courtesy of Richard Koszarski.

[iii] "The Shadow Stage: *We Americans*," *Photoplay*, May 1928, 53.

H. Ince offered six titles through the Bell and Howell Filmo Library, including *Soul of the Beast* (1923).

Pathé offered dozens of features, including several starring popular comedians who had recently transitioned from shorts to features. They included *Spuds* (1927), a World War I comedy directed by star Larry Semon; and *Horse Shoes* (1927), with Monty Banks. The latter was directed by Clyde Bruckman, who had just codirected *The General* (1927) with Buster Keaton. Banks displays a knock-about charm that doesn't quite have the appeal of his contemporary, the all-American Harold Lloyd, but he does have an equal willingness to please.

If these studios chose to squeeze every dollar out of fallow inventory, consider the plight of small independent producers who

# CASE STUDY
## *Directors and 16mm*

While Universal had mostly second-tier stars under contract, several major directors emerged from the studio in the 1920s. For each director, key titles from his Universal period survive only as Show-at-Home prints.

**Clarence Brown** served his apprenticeship at Universal before becoming Greta Garbo's favorite director. His five films for the studio from 1923 to 1925 survive in 16mm, with one also surviving in a somewhat different French 35mm print. These include fascinating variations on the standard romantic triangle, first with *Smouldering Fires*. Pauline Frederick's performance as a middle-aged businesswoman who discovers love for the first time, only to gradually realize that the man prefers her younger sister (Laura La Plante), is immensely moving. Brown further explored the themes of sacrifice and lost opportunity in *The Goose Woman*, with Louise Dresser and Constance Bennett, earning him the assignment to direct Rudolph Valentino in *The Eagle* (1925).

**Erich von Stroheim** was the first important director to emerge from Universal, and three of his four films as director for the studio survive. His final film for the studio, *Merry-Go-Round* (1923), set in a re-creation of his native Vienna, survives only in 16mm. *Blind Husbands* (1919) and *Foolish Wives* (1922) survive in 35mm because the Museum of Modern Art requested 35mm prints from the studio in 1941 and 1936, respectively. Stroheim's intermediate production, *The Devil's Passkey* (1920), met the fate of most Universal productions; the negative was destroyed, no 35mm prints survive, and no Show-at-Home print has been located.[i]

**William Wyler** came to the United States from Germany in 1921. Family ties got him a minor job at Universal, but talent led to his rise: directing two-reel westerns in 1925, then feature westerns, and finally dramas and comedies. A completely forgotten film, *The Shakedown* (1929), reappeared in 1998 at the Cinefest film festival in Syracuse, New York, in a fragile Show-at-Home print borrowed from a collector. The plot, which involves a boxer who has to look after a young boy, is made with confidence and style, and a deep-focus shot in a café looks ahead to Wyler's classics of the 1930s. Critic Leonard Maltin attended that first public screening in modern times, and wrote that "this formulaic but highly entertaining yarn about con artists who run a boxing racket played like gangbusters, and it was plain to see that Wyler was already feeling his oats as a filmmaker, peppering the action with moving-camera and even point-of-view camera shots (one on a huge crane lifting leading man James Murray to the top of an oil derrick)."[ii]

---

[i] The print of *Blind Husbands* acquired by the Museum of Modern Art is the 1924 reissue edition, and *Foolish Wives* is an edition reedited in 1928 for a planned reissue. Richard Koszarski, *Von: The Life and Films of Erich von Stroheim* (New York: Limelight Editions, 2001), 53, 95.

[ii] Leonard Maltin, "Silent Films Live Again!," *Leonard Maltin's Movie Crazy*, July 27, 2010; http://blogs.indiewire.com/leonardmaltin/archives/silent_films_live_again/. *The Shakedown* and another beautiful Universal late silent film, Edward Sloman's *The Girl on the Barge* (1929), were shown by William K. Everson in 1962. He noted that "the two prints are being brought down to our show tonight, and will be taken away immediately afterwards"; http://www.nyu.edu/projects/wke/notes/titles/shakedown.htm. The two films were untraced until 1998. The Italian-release version of *The Shakedown* with music score, titled *Clem Bizzarro Monello*, exists at Fondazione Cineteca Italiana.

could not overlook any source of revenue. A large proportion of surviving silent features are program pictures, because the films were first sold on a states-rights basis to regional film distributors, and then in 16mm to local film distributors and camera stores. Producer Denver Dixon had made several series of Art Mix westerns, starring a Tom Mix look-alike. The president of the company was an Arthur J. Mix, who Dixon found in the Los Angeles phone directory. In 1928, Dixon (real name Victor Adamson), his wife, and his cameraman drove to Oregon, promoted production funding from local businesspersons, and filmed *The Old Oregon Trail*, a very low-budget western

---

*A large proportion of surviving silent features are program pictures.*

---

epic. "Spectacular covered-wagon scenes and beautiful locations provided the backdrop for this story of the settling of Oregon," Sam Sherman wrote. Like many other independent productions, the film survives only in 16mm.[44]

Even more titles were released in 16mm by Universal's Show-at-Home library division. Universal was a minor studio in the 1920s, producing a few big pictures each year and getting by on program films. Light comedies with Reginald Denny and westerns with Hoot Gibson were popular with exhibitors in small towns, where the company's films were most popular.

Because most Universal features were lost in fires or destroyed by the studio in 1948, we would know little about the output of this studio without the Show-at-Home prints. At least 214 silent Universal features were offered by Show-at-Home. Ninety-one have been located and are the only surviving copies. (Another 25 Universal titles released by Show-at-Home also survive in better-quality 35mm copies.)

An additional 61 Universal titles are listed in 16mm rental catalogs from the 1930s and 1940s. These titles are not held by any archives, but collectors may have prints that would allow these films to be recovered.[45]

George Eastman House conducted a worldwide search for Kodascope prints in the 1950s. Although the Kodascope Libraries in the United States closed in 1939, some overseas branches were still in operation at that time. This resulted in the acquisition of 565 features and shorts from Kodak Pathé, Kodak Madrid, Kodak Portugal, and Kodak Rochester, along with some 35mm printing negatives found in storage at Kodak. Eastman House Curator James Card acquired Show-at-Home prints from rental libraries that were closing out their

---

[44] Sam Sherman, "'Go Independent, Young Man': The Maverick Producers," in *Don Miller's Hollywood Corral*, eds. Packy Smith and Ed Hulse (Burbank: Riverwood Press, 1993), 311.

[45] An additional 33 titles were silent editions of all-talking films and outside the scope of this report.

old inventories, acquiring 24 features and shorts from Chicago's Ideal Pictures in 1954.[46]

**16mm Preservation**. In the 1940s and 1950s, archives copied some films only in 16mm. Cost was sometimes a factor, along with a rationale that the less expensive small-gauge was sufficient to capture the content if not the full image quality of the original. Films preserved in this way include 23 produced by Thomas Edison; 7 Mary Pickford features, including her *Tess of the Storm Country* (1922); 6 features starring William S. Hart; and *Barbed Wire* (1927), Pola Negri's finest American film.

Sometimes films were copied in 16mm by rights-holders because that format was sufficient for nontheatrical or television use. Eighteen films from independent producer Thomas H. Ince were prepared for broadcast in the late 1940s, including two dramas starring Louise Glaum as the ultimate vamp—*Sex* and *The Leopard Woman* (both 1920). As archivist David Shepard noted, television wasn't interested and "nothing could have seemed less interesting or more irrelevant than these films. Who in 1950 would be interested by *Dangerous Hours*, a 1920 melodrama of the first 'Red scare' … The second Red scare with characters like Senator Joseph McCarthy made better drama." But many Ince films were preserved in the process.[47]

As the original 28-year copyright term expired for many silent films, distributors began offering 16 and 8mm prints for sale to schools, libraries, and private collectors. These companies would select (and by copying, preserve) only the titles in the public domain. When offered old nitrate prints for potential distribution, the first action for nontheatrical distributor Blackhawk Films was to check the copyright status. According to Blackhawk's company policy, "[We] hold up any attempt to copy or announce for release until we have the report back from the Copyright Office indicating that the word is 'no renewal found.' Then, and only then, do we get to work and make the conversion."[48] The company made 16mm negatives for its purposes, and passed the nitrate to archives.

**9.5mm**. In Europe, the home market was dominated by the Pathé 9.5mm format. Beginning in 1922, the company released numerous features in abridged versions of about 35 minutes. None of these releases is complete, and the small image does not do justice to the quality of the original photography; nonetheless, they do provide a record and a sample of the original work. Prints were prepared with English, French, German, and Spanish intertitles, though not every film was released in each market.

*Fig. 17: Pathéscope Reels. The 9.5mm format was popular in Europe, and Pathé distributed abridged versions of Hollywood films across the continent.*

[46] James Card to author. Also "The Museum's Collections," *Image* 14, no. 5/6 (December 1971): 4. Available at http://image.eastmanhouse.org/.

[47] David Shepard, "Thomas Ince," in *The American Film Heritage*, ed. Kathleen Karr (Washington, DC: Acropolis Books, 1972), 46.

[48] Kent D. Eastin, "Blackhawk Newsreel: How Blackhawk Acquires Distribution Rights to Its Product," *Blackhawk Bulletin*, B-267, September 1975, 75.

Pathéscope released innumerable Hollywood shorts and features on 9.5mm in Europe. These were always abridged versions, renamed for the home market, leading to years of research by British film collectors. For example, Vitagraph's seven-reel *Black Beauty* (1921) was released in 35-minute editions, retitled *Black Bess*, with the appropriate language intertitles for the United Kingdom, France, Italy, and Germany.

Of the 129 American silent features released in abridged versions on 9.5mm, at least 56 exist in no other form. These include two dozen

> *For the first decade of cinema, moving image works were not eligible for copyright protection in the United States.*

films produced by Vitagraph, seven from Warner Bros., a dozen from Triangle, six from MGM, numerous independent films, and, not surprisingly, dozens from parent company Pathé, including numerous Mack Sennett and Hal Roach short comedies and many Pathé features.

Pathé titles included *A Damsel in Distress* (1919), an adaptation of the novel by P. G. Wodehouse, better known for the 1937 RKO remake with Fred Astaire and Joan Fontaine. The Warner Bros. films included three Rin-Tin-Tin titles. Among the independent films are Edward H. Griffith's *White Mice* (1926), with Jacqueline Logan and William Powell, based on the Richard Harding Davis novel of South American intrigue.

One of the most interesting films to survive as a truncated 9.5mm release is the screen adaptation of Booth Tarkington's 1918 Pulitzer Prize–winning novel *The Magnificent Ambersons*, released to theaters in 1925 as *Pampered Youth* and to the 9.5mm market as *Two to One*. There is no evidence that Orson Welles saw the earlier version, or even the 25-minute 9.5mm edition, though *Photoplay* identified the primary narrative weakness in both versions as "a main street story of a spoiled, snobbish, high handed young man." While exhibitors still criticized the film for lack of action, William K. Everson noted that the film concludes with "an extremely well-staged fire sequence which brings the film to a traditional happy ending via the route of thrill and spectacle, somewhat at odds with both the novel and Orson Welles' remake."[49]

**8mm.** Many of the most popular 16mm releases were reissued when Kodak introduced the 8mm format in 1932. Although the image size is only one quarter of 16mm, the quality of the prints was so high that 8mm was perfectly satisfactory for home use. All but two of the 8mm releases also survive in 16mm. One 8mm example, never

---

[49] William K. Everson, *Pampered Youth*, The Theodore Huff Memorial Film Society, November 3, 1969. Available at http://www.nyu.edu/projects/wke/notes/huff/imagefiles/huff_691103.pdf. Everson noted that he was showing "a 16mm blow-up from a badly battered 9.5mm print that Kevin Brownlow rescued from a market-place in France."

released in 16mm, is the Samuel Goldwyn production *Partners Again* (1926), directed by Henry King.

**Paper Prints**. For the first decade of cinema, moving image works were not eligible for copyright protection in the United States. To combat rampant piracy, producers registered their films with the Copyright Office at the Library of Congress as a series of photographs. For submission, many movie negatives were contact printed—not to film, but to photographic paper. "During the period 1893 to 1915, the Library received over 15,000 motion picture copyright registrations from American and foreign producers," wrote Patrick Loughney. Some companies sent in a few frames from each scene printed on paper, while others found it more expedient to send the entire film. "In the case of more than 3,000 of these copyright transactions, the Library acquired complete copies of the original camera negatives printed as positive images onto photographic paper rolls." For 18 American silent feature films, all modern copies originate from one of these paper prints.[50]

Early feature titles (each listed with the copyright claimant) include *Paul J. Rainey's African Hunt* (1912, Carl Laemmle), *The Count of Monte Cristo,* and *The Prisoner of Zenda* (1912 and 1913, both from Famous Players Film Co.), both starring James O'Neill, the actor father of playwright Eugene O'Neill. Theatrical producers Klaw and Erlanger were briefly in the feature film business with adaptations of popular plays starring actors acquired from Biograph after D. W. Griffith's departure. Surviving Klaw and Erlanger features (all from 1914) include *Classmates,* with Blanche Sweet; *Liberty Belles,* with Dorothy Gish; *The Power of the Press* and *The Woman in Black,* both starring Lionel Barrymore; and *The Rejuvenation of Aunt Mary.*

There is also a batch of features from late 1914 and 1915 produced by the New York Motion Picture Corp. under the leadership of Thomas H. Ince, starring William S. Hart (*The Bargain, The Darkening Trail,* and *On the Night Stage*), Bessie Barriscale (*The Cup of Life* and *The Devil*), the novelty feature *Rumpelstiltskin,* and Reginald Barker's *The Italian.*[51]

An amendment to the copyright law in 1912 allowed for the registration of motion pictures, largely ending the submission of paper prints. A few features were still submitted as full-length paper prints. Others producers submitted a few nitrate film frames clipped from

---

[50] For more information on the history and materials contained within the paper print collection, see Patrick Loughney, "Washington, Library of Congress," *Journal of Film Preservation* 49 (October 1994): 33, and Patrick G. Loughney, "A Descriptive Analysis of the Library of Congress Paper Print Collection and Related Copyright Materials," PhD dissertation, George Washington University, 1988. For an overview of the history and restoration of these materials, see Buckey Grimm, "A Short History of the Paper Print Restoration at The Library of Congress," *AMIA Newsletter,* no. 36 (Spring 1997), available at http://www.members.tripod.com/~cinefan/ppart1.htm; and Buckey Grimm, "A Paper Print Pre-History," *Film History* 11, no. 2 (1999): 204–216. For the purposes of this report, paper prints are included in the 16mm category, as they were preserved in 16mm.

[51] For *The Italian,* see http://lccn.loc.gov/91706396. In addition to the paper print, the Library of Congress holds five reels (of a seven-reel version) in the AFI/Irving K. & Mary F. Meginnis collection, and a six-reel version in the AFI/Clement Uhl collection. George Eastman House has a five-reel diacetate 28mm print.

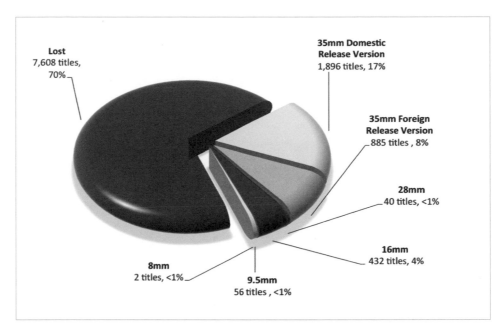

Lost
7,608 titles,
70%

35mm Domestic
Release Version
1,896 titles, 17%

35mm Foreign
Release Version
885 titles , 8%

28mm
40 titles, <1%

16mm
432 titles, 4%

8mm
2 titles, <1%

9.5mm
56 titles , <1%

*Fig. 18: American Silent Feature Film Survival, by Format (complete and incomplete)*

each scene in the feature; Universal Film Mfg. Co. sent in 487 nitrate frame clips from *Traffic in Souls* (1913).

With more than 3,000 early American short films surviving in this collection, as Eric Barnouw noted, "It is ironic that because of the Paper Print Collection, the film years before 1912 now seem better documented than the years immediately following." Once motion pictures qualified for copyright in 1912, the Copyright Office would accept a nitrate print for inspection and then return it to the producer, keeping only a written record of the film, such as a synopsis or pressbook.[52] In fiscal year 1913, the Copyright Office returned 380 motion picture films, with that number increasing to 1,426 in 1914. In fiscal year 1916, as copyright registration became more common, 9,917 features and shorts were inspected and returned.[53]

## Summary of Surviving Film Elements

There is no single number to quantify the survival of American silent-era feature films, as they vary in format and completeness. There are 1,575 titles (14%) surviving in the ideal way—complete domestic-release version in 35mm. Another 1,174 (11%) are complete, but not ideal; they are either a foreign-release version in 35mm or the American version in a small-gauge print with less than 35mm image quality. Another 562 titles (5%) are incomplete and exist in a variety of formats, including a few reels in 35mm, a shortened Kodascope edition in 16mm, and several cut to a third or less of the original in 9.5mm.

---

[52] Introduction by Erik Barnouw in Kemp R. Niver, *Early Motion Pictures: The Paper Print Collection in the Library of Congress* (Washington, DC: Library of Congress, 1985), xvi.

[53] "Report of the Register of Copyrights," Library of Congress Copyright Office, for each year; http://www.copyright.gov/history/index.html. These numbers included features and shorts of both U.S. and foreign origin. Many more films were not registered for copyright.

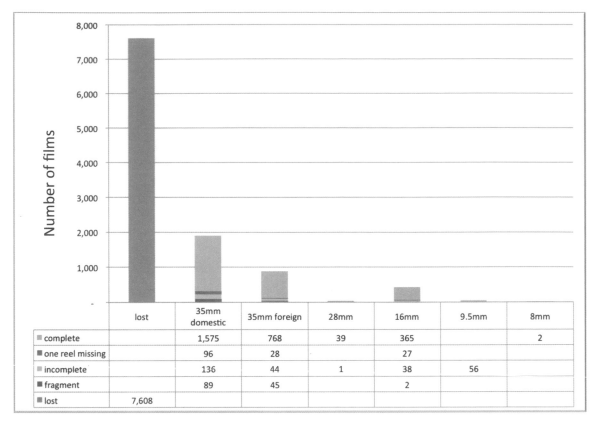

| | lost | 35mm domestic | 35mm foreign | 28mm | 16mm | 9.5mm | 8mm |
|---|---|---|---|---|---|---|---|
| ▪ complete | | 1,575 | 768 | 39 | 365 | | 2 |
| ▪ one reel missing | | 96 | 28 | | 27 | | |
| ▪ incomplete | | 136 | 44 | 1 | 38 | 56 | |
| ▪ fragment | | 89 | 45 | | 2 | | |
| ▪ lost | 7,608 | | | | | | |

*Fig. 19: Statistics for Survival of American Silent Feature Films, by Format and Completeness*

Figures 18 and 19 summarize the information from the previous charts.

In the United States, most surviving films are held in five major film archives. The Packard Campus for Audio Visual Conservation is part of the Library of Congress, the largest library in the world, and the nation's oldest federal cultural institution. The Museum of Modern Art and George Eastman House are parts of museums, and the UCLA Film & Television Archive is within a university. The Academy Film Archive is one of the education, outreach, preservation and research activities supported by the Academy Foundation, part of the Academy of Motion Picture Arts and Sciences.

There are only 23 instances where copies of the same film are held at all five institutions. Each archive has material on D. W. Griffith's *Intolerance* (1916). Director D. W. Griffith had four nitrate prints in storage in 1930—two went to the Museum of Modern Art (along with the negative) in 1938, one was sold by the storage facility to Eastman House after Griffith's death in 1948, and the fourth was purchased by John Hampton and is now at UCLA. What is the value of multiple copies? As Griffith scholar Russell Merritt noted, "There was never a single definitive circulating [version of *Intolerance*]. Today, each of the 'standard' *Intolerance* prints lacks some minor scene or shot, and each one contains some scene, species of intertitle, cluster of shots, shot arrangement, or shot length, that none of the others have."[54]

---

[54] The surprisingly complex path of the various prints and versions of *Intolerance* is discussed in Russell Merritt, "D. W. Griffith's *Intolerance*: Reconstructing an Unattainable Text," *Film History* 4, no. 4 (1990): 369.

The Academy Film Archive has the material prepared by Blackhawk Films, which licensed *Intolerance* from the successor to the director's estate. The Library of Congress has 2,203 nitrate film frames submitted for copyright that were the basis of a 1989 Museum of Modern Art/Library of Congress project to reconstruct the film to the edition seen at its original premiere.

In addition to titles held at multiple institutions, each archive has unique titles in its collection, the result of acquisitions dating back decades. There are 1,270 titles held exclusively by one of the five

---

*A large proportion of the studio films that survive exist because of the willingness of those companies to work cooperatively with archives.*

---

American archives. The Library of Congress has 776 of these titles, a full 61%. This is because of the studio donations, the acquisition of collections as far back as the 1940s, hundreds of titles that came from private collectors, and a large collection of fragments and incomplete prints. Next are George Eastman House (220 titles, 18%), UCLA (144 titles, 11%), the Museum of Modern Art (117 titles, 9%), and the Academy Film Archive (13 titles, <1%). The relatively low number for the Museum of Modern Art is actually a mark of success, as the films rescued by the museum and offered for educational use by the Circulating Film Library became widely available for classrooms and film societies and were placed in commercial distribution by their owners. These included many classics, including films directed by D. W. Griffith, starring Douglas Fairbanks, Buster Keaton, and Rudolph Valentino.

## Source of the Surviving Copies

The major studios played an important role in both the survival and loss of the films that they produced. While it is accurate to point to the past negligence and indifference of corporate owners, and to despair about the lack of studio interest in film preservation through the 1980s from all the companies other than MGM, a large proportion of the studio films that do survive exist because of the willingness of those companies to work cooperatively with archives.

MGM began a comprehensive "nitrate conversion" program in the early 1960s to copy nitrate elements of every film in the vaults to safety film. The value of older films was more significant at the studio, as they had a number of films that showed ongoing commercial value as reissues, ranging from *Gone with the Wind* (1939) to *The Yearling* (1947) and *The Good Earth* (1937). Because the studio owned MGM Laboratories, which had an evening shift to process dailies for films in production, the only added cost of the preservation program was film stock and chemicals.

The studio preserved its entire nitrate film library, including 236 silent feature films. This included films from the companies that

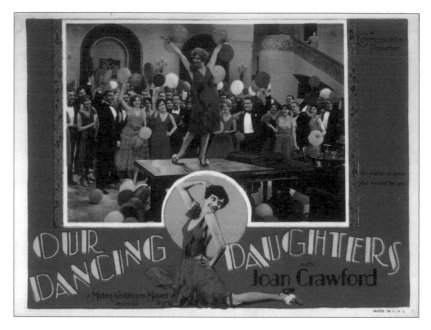

Fig. 20: Our Dancing Daughters (1928)–Lobby Card. If not for MGM's studio preservation program, very little of the company's output would exist today. Our Dancing Daughters is one of more than 200 silent features preserved by MGM Laboratories in the 1960s.

combined to create MGM: Metro Pictures, Goldwyn Pictures, and Louis B. Mayer Productions, and titles such as *La Vie de Boheme* (1916), which had been purchased for their remake value. The studio also preserved films with no apparent commercial value, such as the silent-release version of *The Last of Mrs. Cheyney* (1929), Norma Shearer's second all-talkie, and silent films for which the studio's rights had expired. The studio also located prints of missing films overseas, creating new intertitles when necessary, and restoring recorded-music soundtracks to films with Movietone scores. Starting in 1967, the remaining nitrate was sent to George Eastman House, which had been working with the studio since 1950 to preserve MGM films.

It is striking how few MGM films survive from other sources. If not for the studio preservation program, very little of the company's output would exist.

This study traced the origin of as many surviving copies as possible. As a representative example, many surviving Fox silent features came directly from the studio. *A Fool There Was* (1915), the film that established Theda Bara in her screen persona as a vamp, was requested by the Museum of Modern Art in 1935, and a nitrate print of *East Lynne* (1916), the only other surviving Theda Bara Fox feature, came as part of a major shipment of nitrate prints discovered at the studio in 1968. The only surviving copy of John Ford's *North of Hudson Bay* (1923), with Tom Mix, came from the Czech Film Archive to the Library of Congress in 1969. These acquisitions of 66 copies from the studio and 70 from other sources do not compare to an additional 683 Fox titles that are lost.[55]

---

[55] For background on the rediscovery of Fox silent films in the 1960s, see William K. Everson, "Film Treasure Trove: The Film Preservation Program at 20th Century Fox," *Films in Review*, December 1974. Available at http://www.filmsinreview.com/2012/11/30/film-treasure-trove.

## Studios

It is remarkable that all of today's major studios—Disney, Paramount, Twentieth Century Fox, Universal, and Warner Bros., and the dormant MGM and United Artists—have their roots in companies that were equally dominant in the 1910s and 1920s. Twentieth Century Fox celebrated its 75th anniversary in 2010, but Fox Film Corp. dates to 1914.

Of the 3,311 feature films that survive in any form, roughly 1,699 were produced by one of the major studios or their predecessor companies. Of those, 531 titles passed directly from the studio to an archive or were preserved by the studio. Twice as many, 1,168, have emerged from other sources.

Vanished studios that were major producers in the silent era, such as Triangle and World, ended up in bankruptcy and their films were sold for their remake value. Other companies of equal stature at the time were acquired by more prosperous companies and, in

| PRODUCER | SOURCE OF SURVIVING COPY | | LOST |
| --- | --- | --- | --- |
| | STUDIO | OTHER | |
| Columbia Pictures | 13 | 56 | 58 |
| Pathé | 0 | 121 | 257 |
| Fox Film | 66 | 70 | 683 |
| Goldwyn Pictures | 27 | 53 | 133 |
| Louis B. Mayer Productions | 11 | 3 | 23 |
| Metro Pictures | 53 | 56 | 285 |
| MGM | 128 | 23 | 71 |
| Paramount | 156 | 205 | 861 |
| R-C/FBO | 2 | 123 | 324 |
| Universal | 8 | 252 | 690 |
| Selznick/Select | 8 | 36 | 146 |
| Kalem Co. | 1 | 1 | 19 |
| Vitagraph | 2 | 38 | 312 |
| First National | 33 | 87 | 294 |
| Warner Bros. | 23 | 44 | 120 |
| Total | 531 | 1,168 | 4,276 |

*Table 1: Sources of Surviving Copies of Studio-Owned American Silent Feature Films, Grouped by Owner*[56]

general, stored the old films as inventory until they decomposed or were lost in a fire, junked, or transferred to an archive. Warner Bros., for example, bought out Vitagraph, and maintained the back catalog of negatives. A calamitous fire in 1935 that nearly razed the Burbank

---

[56] Several studios are associated in this chart as a result of mergers and purchases of film libraries. Columbia Pictures bought the Pathé library in 1935. The films produced by the companies that merged in 1924 to form MGM were looked after by the new company. Universal purchased the Selznick/Select library out of bankruptcy in 1924. Warner Bros. absorbed Vitagraph (which had purchased Kalem in 1917) in 1925 and took control of First National in 1928. When possible, these totals exclude films that the studios only released and where rights reverted to the producer, for example, the dozens of Thomas H. Ince productions distributed by Paramount in the late teens and some of the independent producers releasing through First National and Pathé. Surviving copies in this chart include complete and incomplete films.

studio back lot claimed most or all of the Vitagraph negatives.[57]

"Tracking early studio 'film preservation' efforts, or in corporate-parlance, the trajectory of media asset management, proves difficult, if not impossible," noted Caroline Frick.[58] Paramount Pictures presents a representative example of a studio working in cooperation with archives for the protection of its remaining silent films.

**Independent Producers**

Independent producers existed on a different plane than the major studios. They raised their own production funding and relied on other companies for distribution. Independent producers included some of the biggest stars in the industry—Charles Chaplin, Harold Lloyd, Mary Pickford, Douglas Fairbanks, William S. Hart—and major producers such as Thomas H. Ince, Samuel Goldwyn, Howard Hughes, Marion Davies (Cosmopolitan Productions), and, for a while, Cecil B. DeMille. Joseph M. Schenck produced features for his extended family of wife Norma Talmadge, her sister Constance Talmadge, and brother-in-law Buster Keaton.

The survival rate for these films is generally much higher than that of the studio product. Chaplin, Lloyd, Pickford, and Hughes paid for the preservation of their nitrate negatives. The films of Fairbanks, Hart, Davies, and Ince were placed with archives, and as a result most of their films are preserved. Entrepreneur Raymond Rohauer bought the Buster Keaton and Talmadge films, preserving the Keaton titles in the course of making prints for commercial distribution. His estate transferred the Talmadge films, historically important for their depictions of women, to the Library of Congress for preservation.[59]

During a star's lifetime, films were occasionally loaned for screenings or brought out to show to friends. Producer and star Marion Davies kept prints of her films at San Simeon and her estate in Beverly Hills and the negatives in commercial storage. A family friend of Joseph P. Kennedy, Davies attended the wedding of John F. Kennedy and Jacqueline Bouvier in 1953 and offered her Beverly Hills estate for their honeymoon. In her thank you note to Davies, Jacqueline Kennedy wrote that "we saw one of your movies—It was a terrific battle—Jack wanted *Operator 13*—and [Davies' employee] Ingo said we shouldn't see that on our honeymoon—we had to have *Little Old New York*—then we decided on both—but we finally settled for *Going Hollywood*—which I adored." They wisely skipped the 1934

---

[57] "Films Valued as Historical Lost: Early Pictures Destroyed When Flames Rage in Library at Studio," *Glendale News-Press*, December 5, 1934, 1. Thanks to Warner Bros. archivist Leith Adams for providing information on this fire.

[58] Caroline Frick, *Saving Cinema: The Politics of Preservation* (New York: Oxford University Press, 2011), 66. The book is adapted from Caroline Jane Frick's 2005 PhD dissertation, "Restoration Nation: Motion Picture Archives and 'American' Film Heritage." Available at http://repositories.lib.utexas.edu/handle/2152/1915.

[59] For more background on Raymond Rohauer, see John Baxter, "The Silent Empire of Raymond Rohauer," *Sunday Times* (London), January 19, 1975 (this article is not included in the ProQuest digital edition of the London *Times*), and William K. Everson, "Raymond Rohauer: King of the Film Freebooters," *Grand Street*, no. 49 (1994): 188–196.

# CASE STUDY
## *Paramount Pictures*

Paramount Pictures and its corporate antecedents were the dominant studio/distributor/exhibitor until the rise of MGM in the second half of the 1920s. When the company sold its 1929–1948 sound features to a television distributor in 1958, the silent films were excluded because they had no value for television.

Paramount Pictures did not have a preservation program until the 1980s, although they did make new negatives on occasion when it was a necessary step to create a print. For example, *Old Ironsides* (1926) was preserved in 1959 when the studio was preparing a theatrical rerelease with narration. By 1970, the studio had preserved 37 of its silent films, including a few major productions, but mostly minor Wallace Beery comedies and Zane Grey westerns.[i] Hazel Marshall of Paramount's editorial department told the AFI that "these particular films were special favorites of Mr. Zukor's which were kept available in exhibition condition in case Mr. Zukor decided he wanted to see them or have them shown to somebody."[ii]

Although Paramount was not actively preserving its heritage, the company had always been willing to work with archives on a title-by-title basis. The Museum of Modern Art requested its first prints from Paramount in 1935. Curator Iris Barry thought highly of director Josef von Sternberg, writing "in every film that he has made, von Sternberg's highly personal feeling for atmosphere and for texture can be detected." The first six silent features requested by the museum included the director's *Underworld* (1927) and *The Last Command* (1928). Individual requests continued for decades; D. W. Griffith's *The Sorrows of Satan* (1927) was acquired in 1962. George Eastman House established a similar relationship with Paramount. Curator James Card's requests in 1950 included von Sternberg's *The Docks of New York* (1928) and *Beggars of Life* (1928), with Louise Brooks. In 1965, Card inquired about films starring Gloria Swanson and was told that of the 27 silent features she had made at Paramount, 3 remained. Of these, he was able to acquire two: *Her Husband's Trademark* (1922) and *Stage Struck* (1925). By 1971, Paramount had donated 37 silent and sound films to Eastman House.[iii]

Soon after its founding in 1967, the AFI approached the studio to donate its remaining silent-era nitrate to the Library of Congress (predominantly studio reference prints rather than negatives). UCLA had already received authorization to acquire the studio's prints of its 1929–1948 films, and Richard Simonton, Jr., arranged for the transfer of those copies from Paramount's vaults to commercial storage. "There were about two hundred titles not on Paramount's inventory," Simonton recalled, "including

silents from 1914 on and sound films not in the MCA package, either expired properties, independent productions, or otherwise abandoned prints. We began to realize we were uncovering buried treasure."[iv] That treasure, acquired by the American Film Institute (AFI) between 1968 and 1970, included nitrate prints of *The Vanishing American* (1926) and *Redskin* (1929), two of the few Hollywood films to seriously examine the plight of Native Americans. This acquisition was just in time. "In the four years preceding Paramount's [first] gift of about 90 feature films," AFI archivist David Shepard noted at the time, "they had scrapped about 70 silent pictures—in many cases the last copies." And "between November 1968 and the following April when the films were finally shipped, 13 of them had deteriorated."[v]

In 1970, the studio discovered 11 additional negatives and fine-grain masters in a vault in New Jersey. These were titles to which the studio's rights had expired or silent-release versions of sound films. These included the foreign-release versions of *For Heaven's Sake* (1926) and *The Kid Brother* (1927), with Harold Lloyd; two Clara Bow features, *Children of Divorce* and *Get Your Man* (both 1927); and silent-release versions of early talkies: Ernst Lubitsch's *Monte Carlo* (1930) and *True to the Navy* (1930), which is, according to archivist James Cozart, the only Clara Bow silent film of which the original negative survives.[vi] With this last shipment, the studio noted, "Paramount now has no silent film material whatsoever in Hollywood. After we ship the pictures [in New Jersey] to you, Paramount will have no silent film print material whatsoever."[vii]

The UCLA Film & Television Archive worked with Paramount in 1991 on a joint preservation project on the studio's newly discovered nitrate print of *Tess of the Storm Country* (1914). Sometimes studios and archives shuttled films on a two-way street; the studio borrowed back material from archives to create its own preservation materials on *The Covered Wagon* (1923), the Josef von Sternberg films, and *The Wedding March* (1928), among others.

Beyond the 163 Paramount titles in archives that originated from the studio, another 25 films survived only in the collection of director Cecil B. DeMille, who acquired copies of most of his films. Five other titles exist as copyright paper prints, and 11 more titles survive only in 16mm prints distributed by the Kodascope Libraries.

Finally, 160 Paramount features came to domestic and foreign archives from other sources, usually private collectors. The 1916 *Snow White*, which made such an impression on the young Walt Disney that he cited the film

as an inspiration for his own version, was thought to be lost when Disney was preparing his animated version in the 1930s.[viii] A nitrate print in the collection of the Nederland Filmmuseum under the title *Sneeuwwitje En De Zeven Dwergen* was the source for George Eastman House's 1998 restoration.[ix]

The rate of survival for Paramount's 1,222 silent-era features is modest. At most 361 titles (29%) can be located, and that includes incomplete titles and fragments. Of these, 329 are complete prints (in all formats); only 238 (20.4%) survive in complete 35mm domestic-release versions. No matter how you calculate the figures, the low survival rate is disappointing, especially to represent the most successful studio of the silent era. The 153 prints that the studio provided to archives amount to about 2 years of the studio's production from an 18-year period; when supplemented by copies from other sources, the total reaches the equivalent of 5 years of production at most. The survival rate by year ranges from a low of 14% for 1918 and 1928 to 38% for 1926.

---

[i] Paramount Inter-Communication (internal memo), Walter J. Josiah, Jr., Legal Department, to E. Compton Timberlake, Esq., Subject: Silent Film Project, July 15, 1969.

[ii] David Shepard to author, March 16, 2005. Shepard was with the AFI in 1970 and involved with the acquisition of the Paramount collection. For the purpose of this study, "Paramount" includes all the predecessor companies and brands of the current Paramount Pictures.

[iii] "Film Notes. Part 1: The Silent Film," *Bulletin of the Museum of Modern Art* 16, no. 2/3 (1949): 61. Swanson: James Card to Gloria Swanson, June 18, 1965 and December 16, 1965. Gloria Swanson papers, Harry Ransom Humanities Research Center, University of Texas at Austin, box 201, folder 3. The third Swanson title was *The Untamed Lady* (1926). *Zaza* (1923) and *Fine Manners* (1926) were later found at the studio and donated to the AFI/Paramount collection at the Library of Congress. "The Museum's Collections," *Image* 14, no. 5/6 (December 1971): 4. Available at http://image.eastmanhouse.org/.

[iv] Robert S. Birchard, "Nitrate Machos vs. Nitrate Nellies: Buccaneer Days at the UCLA Film and Television Archive," *The Moving Image* 4, no. 1 (Spring 2004): 126.

[v] Austin Lamont, "The Search for Lost Films: David Shepard Discusses the Importance, Methods, Costs and Confusions of Film Archive Work," *Film Comment*, Winter 1971, 60.

[vi] The other titles were *Darkened Rooms* (1929); *Illusion* (1929); *Blonde or Brunette* (1927) with Adolphe Menjou; Herbert Brenon's *Street of Forgotten Men* (1925); and *Forgotten Faces* (1928). Of Clara Bow's ten sound features, the original negative to one title, *Kick In* (1931), survives.

[vii] Letter, Walter J. Josiah, Jr., Legal Department, Paramount Pictures Corporation, to Sam Kula, AFI, June 13, 1969.

[viii] Neal Gabler, *Walt Disney: The Triumph of the American Imagination* (New York: Alfred A. Knopf, 2006), 217.

[ix] Scott Simmon, Program Notes, *Treasures from American Film Archives*, DVD, National Film Preservation Foundation, 2000, 107.

*Fig. 21: Three Silent Paramount Features—*Old Ironsides *(1926), preserved by the studio;* The Last Command *(1928), acquired from the studio by the Museum of Modern Art in 1935; and* Joan the Woman *(1916), in the personal collection of director Cecil B. DeMille.*

Civil War drama; considered, then passed on Davies' 1923 elaborate silent historical romance; and watched her 1933 Hollywood musical with costar Bing Crosby.[60]

In addition to the familiar names, hundreds of entrepreneurs were scrambling to raise funding, preselling distribution rights, and living from one film to the next in Hollywood in the 1920s. If a film wasn't the hoped-for success, negatives would be seized by the bank to cover unpaid loans, or by the laboratory to satisfy a lien for unpaid bills. These films stayed in storage, sometimes producing a small amount of income via 16mm print orders, until, after years of inactivity, they were junked because of decomposition, the owner's unwillingness to pay storage fees for an asset that had no conceivable value, or the inability to trace successors to companies and owners that had gone bankrupt and vanished years before.

Some independent companies did not stay in business long enough to take back their negatives when the distributor's rights expired after five or seven years. Vitagraph contracted with Lariat Productions for a series of five-reel westerns featuring Pete Morrison. By the end of the contract, Lariat Productions and silent films were equally extinct, so the negatives of these "Gower Gulch" westerns stayed with Vitagraph's successor, Warner Bros., which kept them on the shelf. As a result, of the 222 westerns released in 1925, five Pete Morrison features, including *Cowboy Grit* and *The Mystery of Lost Ranch*, survive in pristine original negatives at the Library of Congress.

Fig. 22: The Red Kimono (1926)– Lobby Card. The UCLA Film & Television Archive used a nitrate print as a source for missing reels of this feature film. Thanks to their efforts, the film exists intact today.

An exception for a different reason was Dorothy Davenport Reid, the widow of star Wallace Reid. She became a producer after her husband's death, and her first independent film was *The Red Kimono* (1926), with a screenplay by Dorothy Arzner from a story by Adela Rogers St. Johns. Based on a true case, the film follows a young girl who kills the man who lured her into prostitution in New Orleans and eventually finds love. "Viewed today, *The Red Kimono* is a strong production, lacking the melodramatics that one might expect from such a story," Anthony Slide wrote. In addition, aside from Louis Malle's *Pretty Baby* (1978), this is "perhaps the only feature film to document the Storyville district of New Orleans."[61]

When Dorothy Davenport Reid was approached by the

---

[60] Jacqueline Kennedy to Marion Davies, undated note postmarked 26 September 1953, Marion Davies Collection, Margaret Herrick Library, Academy of Motion Picture Arts and Sciences, Los Angeles. My thanks to Eric Hoyt for inspecting and transcribing the letter.

[61] Anthony Slide, *The Silent Feminists: America's First Women Directors* (Lanham, MD: Scarecrow Press, 1996), 90.

short-lived Hollywood Museum in the early 1960s, she gave them prints of two films starring her husband, *The Roaring Road* (1919) and *Forever* (1921), and the surviving example of the films she produced, *The Red Kimono* negative (already missing two reels). *Forever* decomposed before most of the museum's films were placed with the UCLA Film & Television Archive, which later restored *The Red Kimono*, using a nitrate print as a source for the missing reels.

## Stars and Directors

In 1956, when Cecil B. DeMille accepted the Screen Producers Guild Milestone Award, he told the audience that "the industry will not come of age until it makes a determined effort to keep its own great classics alive—and to present them regularly to the public in a manner worthy of their merit and worthy of the great names who made them."[62]

DeMille was responsible for the survival of 30 films that would otherwise be lost (including two films directed by his brother William, and *Chicago* (1928), which he produced). Colleen Moore had a print of *Irene* (1926); Irene Castle's print of *The Whirl of Life* (1915), with her husband, Vernon, is the only one that survives. Actor Jean Hersholt had a 35mm print of *Alias the Deacon* (1927), one of the less important films of his long career, and 16mm prints of two other titles. Director William Wyler had 35mm prints of most of his sound films, along with two of his silent westerns and the part-talkie *The Love Trap* (1929). Sharing Wyler's sense that the film was memorable was star Laura LaPlante—though her print was the silent version.

These stars and directors were the exception, not the rule. Frank Capra had a print of one of his silent features, *The Way of the Strong* (1928).[63] When asked about the others, he said, "Nobody thought they were important enough to save. You know, the films we were making in those days were just nickel and dime affairs. They were like today's newspaper—you don't save today's newspaper. And when they were finished, nobody expected to ever see them again."[64]

Some other industry personnel sequestered prints at home. Nitrate prints were often stored in garages or in informal vaults in houses, where they quietly turned to goo and powder in the hot Los Angeles summers. Lois Laurel, Stan's daughter, grew up in Beverly Hills and recalled that the fire department would come around in the summer, asking residents if they had any dangerous nitrate film. Her mother turned over their reels, and, as Lois told Richard W. Bann, she "never knew the titles involved, only that her mother had second thoughts later in the day and phoned Stan at the studio to discuss

---

[62] DeMille acceptance speech, January 22, 1956, in *Journal of the Screen Producers Guild* 4, no. 1 (February 1956): 6. Quoted in Robert S. Birchard, *Cecil B. DeMille's Hollywood* (Lexington: University Press of Kentucky, 2004), 48.

[63] Rita Belda, Sony Pictures Entertainment, to author, November 13, 2009. Columbia Pictures junked the negative for *The Way of the Strong* and some other silent titles in November 1949, according to a memo in the AFI files.

[64] Richard Glatzer and John Raeburn, *Frank Capra: The Man and His Films* (Ann Arbor: University of Michigan Press, 1975), 24.

what had happened."[65]

These people did not own the rights to these films—not that they had any commercial value anyway—and there was no permanent film archive on the West Coast that might have looked after them until the founding of the UCLA Film & Television Archive in the late 1960s. Both garages and commercial nitrate film-storage facilities were hot in the summer and cold in the winter; when Frank Borzage gave his 35mm nitrate print of *7th Heaven* (1927) to George Eastman House in 1958, it was already decomposing.

### Private Collectors

Private film collectors have for the most part existed in a parallel world from motion picture archives and moving image academia, acquiring and trading copies of films in all formats and showing them for groups of friends at informal film societies. Film collector Bob Lee ran the longest continuously operating film society in the country, the Essex Film Club in Nutley, New Jersey, from 1939 until his death in 1992. Many archivists, including James Card of George Eastman House and Henry Langlois of the Cinémathèque Française, were collectors before they were curators, and as Paolo Cherchi Usai noted, "If it were not for the drive and persistence of many an unknown Langlois, of anonymous collectors possessed by the nitrate demon, we would have very little to see today."[66]

Fortunately, the collectors who transferred their films to archives are not anonymous, as their names are credited on their collections. The AFI signed its first cooperative agreement with the Library of Congress in 1968, locating titles with companies and private collectors and coordinating acquisition and preservation by the Library of Congress. Significant acquisitions by the AFI before its film preservation program concluded in 2008 include:

- Locally produced films for black audiences: *The Scar of Shame* (1927), made in Philadelphia, and *Eleven P.M.* (1928), made in Detroit, which was acquired from showman Dennis Atkinson.
- *The Birth of a Race* (1918): A black-financed response to *The Birth of a Nation*, from the Panhandle-Plains Historical Museum in Texas.
- *A Tale of Two Worlds* (1921): A Chinese-American girl, Leatrice Joy, is torn between two cultures; acquired from George T. Post, a projectionist in San Francisco.
- *The Heart of Humanity* (1919): One of the most memorable anti-German propaganda films, with Erich von Stroheim as a German officer in occupied Belgium. His atrocities include throwing a crying baby out of a window. Acquired from Donald Nichol.

[65] Richard W. Bann, "Film Preservation—Another Fine Mess," Laurel and Hardy Official Website, April 2011. Available at http://www.laurel-and-hardy.com/archive/articles/2011-04-ucla/ucla-1.html. See also the UCLA Film & Television Archive's project to restore the films of Laurel and Hardy at http://www.cinema.ucla.edu/support/laurel-and-hardy.

[66] For more information on the Essex Film Club, see http://www.essexfilmclub.com. Paolo Cherchi Usai, *Silent Cinema—An Introduction* (London: BFI Publishing, 2008), 77.

The most important collection of films outside an archive or a studio was assembled by John Hampton, who with his wife, Dorothy, managed the Silent Movie Theater in Los Angeles from 1942 to 1979. Hampton bought every silent film in 16mm he could find, and purchased prints and exhibition rights from independents, television distributors, archives, and studios. Many of Hampton's

> *The most important collection of films outside an archive or a studio was assembled by John Hampton.*

copies turned out to be the only known 16mm prints; these are now part of the Stanford Theatre Collection at the UCLA Film & Television Archive.[67]

Another large collection of 16mm titles is in the David Bradley collection of 3,964 16mm prints at the Lilly Library at Indiana University. Bradley was a film enthusiast who became a film director, historian, and collector. His collection of 1,650 pre-1930 shorts and features from around the world overlaps with the Hampton collection, and includes a number of films that survive nowhere else.[68]

## Films Surviving Only in Foreign Archives

### Foreign Distribution

Silent films rapidly became a worldwide medium. The themes of many films were universal, titles could easily be translated, and film distribution was international. Although there was a parochial quality to much American production, the relatively high budgets, technical sophistication, narrative pace, and emphasis on likable screen personalities made them popular wherever they were shown.

The larger companies controlled their own foreign distribution; when the rapidly expanding Warner Bros. bought industry pioneer Vitagraph in 1925, the lure was not Vitagraph's studio or stars, but its sales offices, including 30 exchanges in the United States and Canada, and 20 in England and Europe.[69] Exports of American films to Central Europe increased from 50 reels in 1913 to 20,000 reels annually by 1926. According to a survey that year, in Germany, censors reviewed and passed 251 American features for local exhibition. In Spain, 9 of every 10 playdates were for American films. Small producers had overseas agents to manage their local film sales, while larger companies sublicensed all their releases to a local distributor.[70]

---

[67] Press Release, "Silent Film Collection Deposited at UCLA Film and Television Archive," June 1999; http://old.cinema.ucla.edu/PR/packard.html.

[68] For information on David Bradley's career and his collection, see http://www.libraries.iub.edu/index.php?pageId=1002901.

[69] "Vitagraph Company Purchased by Warner Bros.," *Motion Picture News*, May 2, 1925, 1929.

[70] George R. Canty, American Trade Commissioner, "Market for Motion Pictures in Central Europe, Italy and Spain," *Trade Information Bulletin No. 499* (Washington, DC: United States Department of Commerce, 1927), 20. Central Europe consisted of Germany, Poland, Czechoslovakia, Austria, and Hungary.

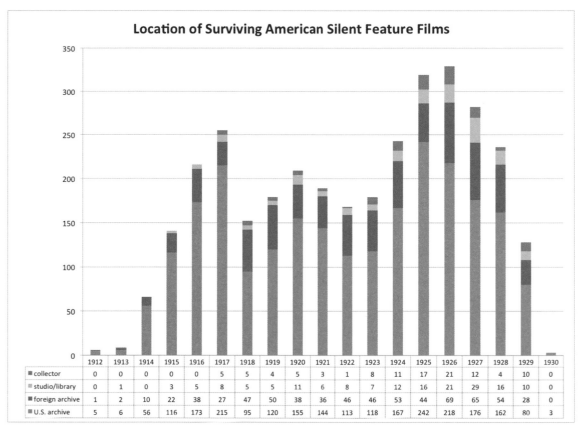

**Location of Surviving American Silent Feature Films**

| | 1912 | 1913 | 1914 | 1915 | 1916 | 1917 | 1918 | 1919 | 1920 | 1921 | 1922 | 1923 | 1924 | 1925 | 1926 | 1927 | 1928 | 1929 | 1930 |
|---|---|---|---|---|---|---|---|---|---|---|---|---|---|---|---|---|---|---|---|
| ■ collector | 0 | 0 | 0 | 0 | 0 | 5 | 5 | 4 | 5 | 3 | 1 | 8 | 11 | 17 | 21 | 12 | 4 | 10 | 0 |
| ■ studio/library | 0 | 1 | 0 | 3 | 5 | 8 | 5 | 5 | 11 | 6 | 8 | 7 | 12 | 16 | 21 | 29 | 16 | 10 | 0 |
| ■ foreign archive | 1 | 2 | 10 | 22 | 38 | 27 | 47 | 50 | 38 | 36 | 46 | 46 | 53 | 44 | 69 | 65 | 54 | 28 | 0 |
| ■ U.S. archive | 5 | 6 | 56 | 116 | 173 | 215 | 95 | 120 | 155 | 144 | 113 | 118 | 167 | 242 | 218 | 176 | 162 | 80 | 3 |

*Fig. 23: Location of Surviving American Silent Feature Films*

American film stars were sometimes startled by their international fame. When Mary Pickford and Douglas Fairbanks visited Russia in 1926, "we were fairly sure of a cordial reception in Moscow," the actress recalled, "but we were not one whit prepared for the staggering crowds, estimated at one hundred thousand, that met us at the station."[71]

It was "not only the tremendous vigor of the American film technique," a Czechoslovak historian wrote. "There were, in the first place, tremendous financial resources and a huge business organization which resulted in the complete success of the American film invasion into the rest of the world. And in this flood of imported American films the Czech film waned."[72] In Czechoslovakia, 35 feature films were produced in 1926 (at an average cost of $6,000) to serve a domestic market with 720 film theaters.[73] American films were the most popular with Czech audiences, and most American companies had a local representative. As the United States Commerce Department noted, "The four American firms maintaining branches in Prague dispose of their films on a rental basis, though ... owing to the overstocking of the market with American

[71] Mary Pickford, *Sunshine and Shadow* (New York: Doubleday & Company, Inc., 1955), 279.

[72] Jindrich Brichta, "The Three Periods of Czechoslovak Cinema," in *The Penguin Film Review,* v. 3, ed. Roger Manvell (London: Penguin Books, 1947), 56.

[73] The American Trade Commissioner identified 12 Czech feature films produced in 1926, while modern research has identified 35. See *Czech Feature Films I: 1898–1930* (Praha: Národní Filmový Archiv, 1995), 258–259.

films, it is often necessary to adopt other means to dispose of its
stock."[74] In such circumstances, there were many opportunities for
prints to leak into the private market. Those aging copies served as
unadvertised second features in small-town theaters or were offered
by touring showmen in rural areas. Eventually those prints were
sold for silver salvage  bought by collectors.

A combination of factors resulted in a large number of unique
prints surviving in the Národní Filmovy Archiv in Prague, founded
in 1943. "Some [films were donated] in the spirit of preserving the
country's film heritage," a publication noted on the archive's 60th
anniversary, while "others were simply abiding by the law, which
nationalized all film enterprises in 1945." The Czech film archive's
first large acquisition was in the late 1940s, a collection of about 400
silent-era features and shorts from a Mr. Bouda, the manager of a
traveling cinema.[75]

In 1966, the archive responded to a call from a small Czech vil-
lage about another collection from a traveling exhibitor, Mr. Pisvejc,

---

*The recoveries from the Czech archive are*

*almost too many to mention.*

---

who had stored his films at a chicken farm. "To my great surprise,
I unearthed from under a layer of chicken droppings about half a
metre thick around 80 tinted feature films from the 1920s, largely
Westerns starring Tom Mix, Buck Jones and so on," archivist
Vladimir Opela recalled. "What we had found were the films that
had been programmed in Mr. Pisvejc's cinema."[76]

The recoveries from the Czech archive are almost too many to
mention: films from directors John Ford, Henry King, Tod Browning,
Maurice Tourneur, and William Wellman; at least 20 Tom Mix fea-
tures; the only nitrate copy of *Ben-Hur* (1925) with the original
Technicolor sequences; and the Colleen Moore comedy *Her Wild Oat*
(1927). All these films have been preserved, and many have been ac-
quired by U.S. archives.[77]

### American Films Recovered from Foreign Archives
Contributions from other archives, while not as numerous as those
from the Czech collection, have proved to be equally important
to recovering important American films and filling gaps in the ca-
reers of directors and stars. Only 3 of the 19 silent features made by

---

[74] Ibid.

[75] Vladimir Opela and Blazena Urgosikova, "60 years of the National Film Archive,"
(Prague: Národní Filmový Archiv, 2003), 11.

[76] Vladimir Opela, "Les Miracles ont Lieu non Seulement une Fois," in *This Film Is
Dangerous: A Celebration of Nitrate Film*, eds. Roger Smither and Catherine A. Surowiec
(Brussels: Fédération International des Archives du Film [FIAF], 2002), 573. Also
Vladimir Opela interviews with author, June 6, 2000, and November 7, 2009.

[77] In addition, more than 100 silent slapstick comedies not known to exist in the United
States were transferred to the Museum of Modern Art.

pioneering black director Oscar Micheaux survive, and 2 of the 3 were found in foreign archives. Japanese actor Sessue Hayakawa was an unlikely but popular star in 1910s Hollywood; three of his films survive only in foreign editions with Dutch titles.

Some of the key missing American films recovered from foreign archives include:

**National Film and Sound Archive** (Canberra, Australia)
- Maurice Tourneur's *Alias Jimmy Valentine* (1915)

**Cinémathèque Royale de Belgique** (Brussels, Belgium)
- Oscar Micheaux's *The Symbol of the Unconquered* (1920)

**Nederlands Filmmuseum** (now EYE Film Institute Netherlands) (Amsterdam, Netherlands)
- Frank Borzage's *Lucky Star* (1929) with Janet Gaynor and Charles Farrell
- Sam Wood's *Beyond the Rocks* (1922), with Gloria Swanson and Rudolph Valentino

**The New Zealand Film Archive** (Wellington, New Zealand)
- John Ford's *Upstream* (1927)

**Cinémathèque Française** (Paris, France)
- *The Dragon Painter* (1919) with Sessue Hayakawa
- Paul Fejos' *Lonesome* (1929)
- Maurice Tourneur and Clarence Brown's *The Last of the Mohicans* (1920) and *The Foolish Matrons* (1921)
- Tod Browning's *The Unknown* (1927) with Lon Chaney
- Ernst Lubitsch's *Three Women* (1924)
- Frank Capra's *The Matinee Idol* (1928)

**National Film and Television Archive** (British Film Institute) (London, UK)
- D. W. Griffith's *True Heart Susie* (1919) with Lillian Gish
- Herbert Brenon's *Laugh, Clown, Laugh* (1928) with Lon Chaney

**Gosfilmofond** (Moscow, Russia)
- D. W. Griffith's *A Romance of Happy Valley* (1919) with Lillian Gish
- Ernst Lubitsch's *Rosita* (1923) with Mary Pickford
- Victor Fleming's *The Call of the Canyon* (1923) with Richard Dix

**Jugoslovenska Kinoteka** (Belgrade, Serbia)
- *Anna Christie* (1923) with Blanche Sweet
- Frank Lloyd's *Oliver Twist* (1922) with Jackie Coogan and Lon Chaney

**Danske Filmmuseum** (now Det Danske Filminstitut) (Copenhagen, Denmark)
- William Desmond Taylor's *Huckleberry Finn* (1920)
- Frank Capra's *The Way of the Strong* (1928)

No filmmaker's output demonstrates the important role of foreign archives as well as does that of director John Ford. He started his feature career with westerns—10 shorts and 28 features at Universal. The only three features to survive from this period of his

career were found in France and Czechoslovakia. Ford's 26 films at Fox in the 1920s are better represented, with 9 originating from the studio, along with 3 from the Czech film archive, 2 incomplete titles from American film collectors, and the 2010 discovery of *Upstream* (1927) at the New Zealand Film Archive in Wellington, which the archive acquired from a private collector.

Even when films survive in the United States, the foreign versions often provide crucial missing material. For the UCLA Film & Television Archive restoration of *The Sea Hawk* (1924), the American studio copy provided the bulk of the picture, but was lacking the epic sea battles and the climactic chase that had apparently been removed for stock footage. The gaps in the narrative (along with a hand-colored sequence)—a total of 17 minutes—were recovered with material from prints provided by the Czech archive and private collector Robert Israel.[78]

Fig. 24: Tom Mix in Oh, You Tony! (1924)–Lobby Card. For hundreds of American silent films, the only known copies have been found overseas. This Tom Mix feature was discovered in Czechoslovakia.

### Identification and Repatriation

Before the AFI catalogs with information on all feature releases were published, the biggest challenge was to identify prints in foreign archives, as titles of films were often changed for foreign markets. Odd reels might be cataloged as "unknown" or "unidentified Tom Mix." The Czech-language release *Tom Mix, Cowboy-Kavalir* turned out to be Mix's fifty-third feature for Fox—*Oh, You Tony!* (1924)—while his next, *Teeth* (1924), was released by local distributor Monopol Elekta Film as *Tom, Tony, Tygr*.[79]

Overall, of the 3,311 American silent feature films that survive in any form, 886 were found overseas. Of these, 210 or 23% have already been repatriated to an American archive. "Repatriation was an important element of FIAF's international platform," Paul Spehr recalled. "It was a recommendation that dates back to the founding of the organization."[80] Most of the recovered films were brought back a title at a time, although there were large-scale repatriations from the Australian National Film and Sound Archive in the 1970s and 1990s, the New Zealand Archive in the late 1980s and again in 2010, and the Nederlands Filmmuseum in the early 1990s.

"The return of national product to the archives concerned with their preservation was encouraged, and was the reason for the

---

[78] Kenneth Turan, "A Bounty of Rescued Celluloid Movies: The 1924 '*Sea Hawk*' Launches UCLA's Monthlong Festival of Preservation Tonight," *Los Angeles Times*, April 7, 1994, 1, Calendar; Part F. Additional information provided in author's interview with Robert Israel, January 22, 2011.

[79] Prints of these Czech editions are now at the Library of Congress.

[80] E-mail, Paul Spehr to author, July 20, 2011. Spehr was at the Library of Congress from 1958 to 1993, retiring as the assistant chief, Motion Picture, Broadcasting and Recorded Sound Division.

publication of lists of features and shorts held by member archives," Spehr noted.[81] In 1977, FIAF published a list of worldwide silent film holdings, including 1,455 American features held in member archives. The list has been periodically updated, currently on CD-ROM and online. The past decade has seen a groundswell of discoveries of silent features that had been thought lost, as archives have acquired additional nitrate collections and cataloged materials that have been in the collection for a long time, but not identified. As the deputy director of the Nederlands Filmmuseum noted on the 1990 "rediscovery" of Frank Borzage's *Lucky Star* (1929), "This famous Borzage film was not a discovery of the Nederlands Filmmuseum. It was well known that the print existed and was in fairly good shape, but it had to wait for preservation because there were other priorities and urgencies."[82]

Trading between collections is as old as archives themselves. One of Iris Barry's first acts for the newly formed Museum of Modern Art was to travel to Germany, the U.S.S.R., and Sweden in 1936 to acquire prints for the collection. The museum's Eileen Bowser recalled the importance of "film exchange with other archives, especially recovering lost American films in European archives. Again, this was where FIAF played a very important part, because those exchanges were made on the basis of personal relations more than anything else. You'd sit down and talk with people and talk about films and what they have and what they want. That's how the real gems come into a collection."[83]

The Museum of Modern Art provided a newsreel showing the Russo-Japanese war to the Gosfilmofond archive in Moscow in return for D. W. Griffith's *The Romance of Happy Valley* (1919). To acquire Oscar Micheaux's *Within Our Gates* (1920) for the Library of Congress, the Filmoteca Española in Madrid received a print of *Dracula* (1931).[84]

In 2010, the Library of Congress acquired 10 lost American silent feature films as a gift from the Boris Yeltsin Presidential Library. The films were preserved by the Russian film archive Gosfilmofond, and digital copies were presented to Librarian of Congress James H. Billington. Up to 200 American features are thought to exist only in the Gosfilmofond collection, and future exchanges will expand Library of Congress holdings. Also, an agreement was signed in 2011 between the Library and the Archives du Film du CNC (Centre national du cinéma et de l'image animée), the French national film

---

[81] Ibid.

[82] Eric de Kuyper, "Anyone for an Aesthetic of Film History?" *Film History* 6, no. 1, (Spring 1994): 107.

[83] Ronald S. Magliozzi, "Film Archiving as a Profession: An Interview with Eileen Bowser," *The Moving Image* 3, no. 1 (Spring 2003): 139–140. Available at http://muse. jhu.edu/journals/the_moving_image/v003/3.1magliozzi.html.

[84] Howard Thompson, "Icy Vaults Spare Films a Moldy Death," *New York Times*, March 10, 1969, 52. See also the conference program for "Faded Glory: Oscar Micheaux and the Pre-War Black Independent Cinema," February 6–7, 2009, New York, NY. Available at http://thebioscope.net/2009/01/28/faded-glory/.

*Fig. 25: Chicago (1928)–Lobby Card. Previously unseen silent films continue to emerge for public screenings. Chicago was screened at the UCLA Film & Television Archive's 13th Festival of Preservation in 2006.*

archive at Bois D'Arcy, for the return of nitrate copies of American films from France.[85]

## The Likelihood of Future Discoveries

Although silent films would seem to be a finite resource—no one is making any new 1917 melodramas—the fact that previously unseen films continue to emerge for public screenings and festivals means that the canon has been regularly refreshed with new discoveries. Memorable events include Harold Lloyd presenting his compilation *Harold Lloyd's World of Comedy* at the 1962 Cannes Film Festival; the brilliant *Exit Smiling* (1926), with English comic actress Beatrice Lillie, at the 1969 New York Film Festival; the restored *Ben-Hur* (1925), with a full orchestra conducted by Carl Davis at the London Film Festival in 1987; Frank Borzage's *Lucky Star* (1929), shown at the 1990 Giornate del Cinema Muto in Pordenone, Italy; and Frank Urson's *Chicago* (1928), screened at the UCLA Film & Television Archive's 13th Festival of Preservation in 2006.

As archives have worked through their backlogs, more "lost" American films have emerged. Several foreign archives have determined that only domestic production fits their mission so they work with U.S. archives to return American material, while others want to

---

[85] The gift of titles from Russia includes five films originally released by Paramount: *The Valley of the Giants* and *You're Fired* (both 1919, directed by James Cruze, with Wallace Reid); *The Conquest of Canaan* (1921) with Thomas Meighan; George Fitzmaurice's *Kick In* (1923); and Victor Fleming's *The Call of the Canyon* (1923), from a Zane Grey story with Richard Dix. Other titles include *Canyon of the Fools* (1923), with Harry Carey; *Circus Days* (1923), with Jackie Coogan; Reginald Barker's *The Eternal Struggle* (1923); Rex Ingram's *The Arab* (1924), with Ramon Novarro; and *Keep Smiling* (1925), with Monty Banks. For more information, see Sheryl Cannady and Donna Urschel, "Spasibo, Russia: A Gift of Silent-Era Gems," *Library of Congress Information Bulletin*, December 2010. Available at http://www.loc.gov/loc/lcib/1012/films.html.

keep and preserve the American films that dominated their country's theater screens.

It can be argued that no films are lost—they just haven't been found yet—but the odds are against that optimistic interpretation. Some 130 Fox features are known to survive (in some form) out of 820 films produced. Even if one "lost" Fox film emerges each year, that gap will never close.

Another factor is the limited life expectancy of nitrate film. While some 100-year-old nitrate film exists, most nitrate film acquisitions have some amount of deterioration; the number of films that survive incomplete is an indication of films that were acquired or preserved not quite in time.

This is not always straightforward. Henri Langlois knew his archive included a print of Tod Browning's *The Unknown* (1927), with Lon Chaney as the armless knife thrower hopelessly in love with carnival girl Joan Crawford. In the 1960s, when Eastman House asked to borrow the print for preservation, it took the Cinémathèque Française years to locate it, as there were hundreds of cans in the collection marked *Inconnu* (Unknown).[86]

The search for missing films no longer focuses on the studios, as they have placed all their silent film nitrate prints and negatives with archives. The last big cache of material emerged when Twentieth Century Fox closed down its Ogdensburg, New Jersey, vaults in 2002 and transferred the nitrate prints to the Academy Film Archive.

The search by American archives for missing American silent films will now focus on locating titles held in foreign archives and private collections and on documenting previously unidentified films. As the major companies ensured that few prints escaped their control, found films are more likely to be the product of independent producers than of the big studios. A search for *The Divine Woman* (1928), one of the films that Greta Garbo made for MGM (only one reel found in Russia survives), is much more likely to uncover *Divine Sinner* (1928), a Poverty Row quickie from Rayart Pictures featuring former DeMille star Vera Reynolds.

## Additional Considerations

While the percentage of surviving American silent feature films is dismayingly low, the general quality of what does survive is high enough to make the loss that much more significant. Some conclusions emerged while researching this report.

**Is everything worth saving?** It is impossible to determine in advance which films will stand the test of time as art, or which will prove significant as a social record. With so many gaps in the historical record, every silent film is of some value and illuminates different elements of our history.

Many of the Poverty Row films were ignored at the time and would be of equally low value today. More than 1,500 silent westerns

---

[86] David J. Skal and Elias Savada, *Dark Carnival: The Secret World of Tod Browning* (New York: Anchor Books, 1995), 116.

were produced—how many B westerns do we need? *Big Stakes* (1922), with J. B. Warner, is one of those 1,500 westerns. "It is not a great picture by any means," Robert S. Birchard wrote, "but it is one of the most beautifully tinted and toned silents you'll ever see." And the plot elements—a Hispanic romantic interest, vigilante night riders—are more interesting today than in 1922.[87]

**Archives originally had the resources to collect only individual films, not entire collections.** It is ironic that in the 1930s, 1940s, and 1950s, when many more silent films still existed, the resources to acquire, store, and preserve films were minimal. Now that the money is available, the films are not. Why didn't archives acquire more films in the early years?

Fig. 26: King Vidor's The Crowd (1928)–Poster. This important film was selected for the film archive at the George Eastman House in 1952, ensuring that it would survive to be seen by modern audiences.

The curators recognized that financial support was limited, that the support of rights-holders was tenuous and easily lost, and that parent institutions had other priorities. Aware that it was not possible to save everything, they focused on rescuing the most important films. The Museum of Modern Art was most active in acquisitions from 1935 to 1941, during the establishment of the circulating film library. The Library of Congress had a brief burst of collecting activity from 1944 until 1947, the year when the Motion Picture Division was summarily closed at the direction of Congress. George Eastman House began collecting film in 1948. The perennial lack of funding limited acquisitions and ensured that all these activities were on a small scale until the late 1960s, when the National Endowment for the Arts began providing significant financial support.

**Curatorial selection has been the key to the survival of important silent films.** Until the late 1960s, archives were acquiring a few titles at a time. As a result, "the criterion of selectivity became an end in itself, as a virtue was made of necessity," Andrew Sarris wrote. "Since relatively few films could be preserved and re-exhibited, the ones that were had to be certified as esthetically exemplary."[88] The process of selection for the Museum of Modern Art Film Library by Iris Barry and her successors holds up well on artistic and cultural grounds.

What did the museum miss? There have been laments since the very beginning over choices.

"There are many old pictures now locked in studio storerooms which might seem to certain individuals to be preferable to some the Film Library has," *New York Times* critic Bosley Crowther wrote in 1943. "This corner wishes, for instance, that it had picked up a print of King Vidor's *The Crowd* (1928)."[89] Eastman House had even less funding and infrastructure, so curator James Card consciously tried to acquire in areas that had not been of interest to the Museum. "The

---

[87] Robert S. Birchard, "Banished from Preservation," posting at nitrateville.com, June 8, 2010. Available at http://www.nitrateville.com/viewtopic.php?p=33661.

[88] Andrew Sarris, "MOMA and the Movies," *ARTnews*, October 1979, 110.

[89] Bosley Crowther, "Ring in the Old," *New York Times*, September 26, 1943, X3.

selections of the Museum of Modern Art were governed by only one criterion, and that was Iris Barry's taste," Card recalled. "If she didn't like *The Crowd*, for example—which she didn't—no print."[90] Card ensured that *The Crowd* was on his first list of requests to MGM, and he acquired a print for Eastman House in 1952.

**The public domain status of some films has encouraged their survival.** The United States copyright on most studio silent features was renewed. The copyright on almost all independent films expired, as for the most part, their producers were no longer in business and there was no one to file the renewal.[91]

Copyright protection should have increased the economic incentive of a studio to preserve its silent films, but MGM was the only company to do so as a matter of policy. Copyright could not have been MGM's primary motivation, as the studio also preserved at least 43 features to which the studio's rights had expired and the company had no ownership. And valid copyrights were not sufficient to encourage other studio rights-holders to invest in their silent libraries.

Some small producers, such as Charlie Chaplin, Mary Pickford, and Harold Lloyd, owned the films in which they starred. They preserved their films regardless of copyright status. The public domain status of films produced by independent companies (such as the films Cecil B. DeMille produced at his own studio) led to their acquisition by entrepreneurs who preserved them in the course of commercial exploitation. In 1956 television distributor Paul Killiam bought the negative to Cecil B. DeMille's *The Road to Yesterday* (1925) after the film fell into the public domain and preserved it. Nontheatrical distributor Blackhawk Films preserved dozens of features and hundreds of short films in the public domain.

**One copy is sufficient for a film to survive.** Some silent films are so ubiquitous that one wonders how any film could be lost. Innumerable duplicates often can be traced back to a single copy. The one 35mm original print of *The Phantom of the Opera* (1925), with Lon Chaney in his iconic role, was acquired by Eastman House in 1950, just as the nitrate was starting to decompose. This print, readily identifiable by deterioration in one scene, is in the collection of no less than 16 other archives (no doubt as a result of trades to add other treasures to the Eastman House collection), and is widely available commercially, including by Universal, which made

Fig. 27: John Barrymore in Beau Brummel (1924)–Poster. While many films are lost, Beau Brummel survives in four different original copies.

---

[90] Herbert Reynolds, "'What Can You Do for Us, Barney?' Four Decades of Film Collecting: An Interview with James Card," *Image* 20, no. 2 (June 1977): 19. Available at http://image.eastmanhouse.org/node/117.

[91] For a detailed account of the copyright status of studio libraries, see David Pierce, "Forgotten Faces: Why Some of Our Cinema Heritage Is Part of the Public Domain," *Film History* 19, no. 2 (2007): 125–143.

its copy from the Eastman House print.[92]

Consider the case of *Beau Brummel*, Warner Bros.'s first film with John Barrymore, opposite a young Mary Astor. The film was on the *New York Times* list of 10 outstanding pictures for 1924, and reviews praised Barrymore's performance. *Beau Brummel* continued to be available when it was released in 16mm by the Kodascope Libraries in 1925 (cut from 10 reels to 7). The Museum of Modern Art acquired a complete print in 1935, and the film was available for educational screenings starting in 1936. Even though Warner had sold its rights to MGM for the 1954 remake with Stewart Granger and Elizabeth Taylor, the studio retained a nitrate print (deposited with UCLA in 1970). Meanwhile, MGM had retained the silent negative and made safety film preservation copies in the 1960s. The restored version, with a new score, premiered on Turner Classic Movies in 2008, and that version was subsequently released on DVD by the Warner Archive website.

Yet in the face of that one film surviving four times over, where is *The Great Gatsby* (1926)? The last known screening was in 1947, when the studio print was shown to consider its remake possibilities. "D. A. Doran, the head of the story department, set up a screening of the 1926 film," screenwriter DeWitt Bodeen recalled. "The print kept breaking, so I'm not surprised that it's now listed as 'lost.'"[93]

Now, 80 years after the release of the last silent features, how angry should we be at the loss of these films? As Euripides wrote, "Whom the gods wish to destroy, they first make mad."

## Conclusions and Recommendations

The task of preserving what remains of America's silent feature film heritage is manageable, as American archives benefit from a high profile, financial support, and an unprecedented level of public awareness. The challenge for American film archives is to build on those strengths and provide wide public access to this patrimony.

*Recommendation 1:* **Develop a nationally coordinated program to repatriate U.S. feature films from foreign archives.**

One-quarter of extant American silent feature films (886 of 3,311) survive only in foreign-release versions, found outside the United States, usually with titles translated into the local language. Only 210, or 23%, have been repatriated to an American archive, leaving copies of 676 titles (many incomplete) located only overseas.

Most national archives accept preservation responsibility only for their domestic production, so at least some of these films are at

---

[92] Scott MacQueen, "The 1926 *Phantom of the Opera*," *American Cinematographer*, September 1989, 35–40. Scott MacQueen, "*Phantom of the Opera—Part II*," *American Cinematographer*, October 1989, 34–40. The print that Universal provided to George Eastman House was identified by MacQueen as the international release version from 1930, differing significantly from the original release and the part-talkie reissue. The original-release version survives only in 16mm.

[93] DeWitt Bodeen, "Hollywood and the Fiction Writer," preface to Gene D. Phillips, *Fiction, Film, and F. Scott Fitzgerald* (Chicago: Loyola University Press, 1986), xvii.

risk of loss. And the international dispersion of the surviving heritage of American silent features limits the utility of these works for research by American scholars.

These titles should be reviewed and priorities established for repatriation to the United States. Titles at risk—those that have yet to be preserved on safety film—should be preserved on film, with film or digital copies acquired for American archives. Titles not at risk can be acquired in either film or digital form.

*Recommendation 2:* **Collaborate with studios and rights-holders to acquire archival master film elements of unique titles.**

Many of the films preserved by MGM in the 1960s still are not held by any American archive, and the other studios may have some unique material. A comparison of holdings between archives and studios will likely identify additional titles held only by the rights-holders.

Placing these elements in archives would provide the studio with an additional set of preservation elements in first-class storage that it could access in the future if required. The archives would benefit from adding previously inaccessible titles in their collection, which they could then make more available to the public.

*Recommendation 3:* **Encourage coordination among U.S. archives and collectors to identify silent films surviving only in small-gauge formats.**

This project identified many films held outside of FIAF archives in nonarchival collections. Acquisition of 16mm prints has usually been a lesser priority for archives traditionally focused on nitrate acquisition and preservation. Working from old distribution catalogs, it is straightforward to identify what films were released on home library gauges of 28mm, 16mm, and 9.5mm.

These known releases not held by FIAF archives include 15 Kodascope features, 61 Universal Show-at-Home features, and 118 additional features that were released in 16mm. Other formats include 13 titles in 28mm and 50 titles in 9.5mm abridgements.

Small-gauge releases have been located with collectors and could be the subject of a focused nationwide "lost film" search with a specific list of titles. A focused outreach program would provide an opportunity to identify copies that still survive in private hands.

*Recommendation 4:* **Focus increased preservation attention on small-gauge films.**

The greatest cache of unexplored surviving titles are the 432 American silent feature films that survive only in 16mm. Because of the volume of material and smaller image size (16mm has just one-sixth the image area of 35mm), these titles are ideal candidates for digital image capture and preservation. Although they do not have the fire risk of 35mm nitrate film, the 16mm prints date to the 1920s and 1930s, and the diacetate film stock that was used at the time is at great risk of shrinkage, brittleness, and vinegar syndrome.

Most film collectors want to keep their copies; digital scanning would allow high-quality preservation, with restoration to follow, while the film copies could be returned to their owners.

*Recommendation 5:* **Work with other American and foreign film archives to document "unidentified" titles.**

All archives have films in their collections that are unidentified, sometimes because they are missing the main title or labels on the original cans. Just as often, the name of the film was changed for the local market and the country of origin is not apparent. An aggressive campaign to identify unknown titles could recover important films.

Archives have occasionally sponsored showings of unidentified films with some success. A number of films also have been identified through Internet crowdsourcing by experts who view film frames posted online and suggest possible titles. An Association of Moving Image Archivists (AMIA)-sponsored group on Flickr posts images from unidentified films, mostly from American archives. The German site "Lost Films," initiated by the Deutsche Kinemathek with archive partners across Europe, has a section with frame images and invites visitors to help locate copies of lost films and to identify images from unidentified films.[94]

*Recommendation 6:* **Encourage the exhibition and rediscovery of silent feature films among the general public and scholarly community.**

The number of America's silent feature films surviving in complete, 35mm copies as originally released is a disappointingly low 14% (1,575 of 10,919 features). This percentage can be bolstered by including foreign-release versions in 35mm (7%) and small-gauge (3.5%) copies. If the definition of "surviving" is expanded to include incomplete copies and fragments, another 562 titles (5%) can be added to the list. But as shown in Figure 28, the 3,311 surviving films still pale in comparison to the 7,608 titles for which there is no film material at all.

Although a qualitative study of surviving-versus-lost titles is beyond the scope of this report, it seems likely that more than 14% of the most important commercial and artistic American feature films survive in complete, 35mm editions. Starting in 1920, *Photoplay* magazine presented a Medal of Honor for the best film of the year as chosen by its readers. Eight of the nine silent films to receive that award survive.[95]

---

[94] The AMIA Nitrate Film Interest Group sponsors a Flickr account at http://www.flickr.com/people/nfig/. The Deutsche Kinemathek Lost Films site is at http://www.lost-films.eu/. An overview of the German site is described by Paul Collins in "The Silence of the Silents: A Heroic Wiki Project to Identify Lost and Orphaned Films," *Slate*, July 8, 2010. Available at http://www.slate.com/id/2257833/.

[95] Between 1920 and 1928, the films were *Humoresque, Tol'able David, Douglas Fairbanks in Robin Hood, The Covered Wagon, Abraham Lincoln, The Big Parade, Beau Geste, Seventh Heaven,* and *Four Sons.* All but *Humoresque* and *Abraham Lincoln* were selected by the Museum of Modern Art for its collections, and all but *Abraham Lincoln* survive complete. The biography of the sixteenth president survives in an abridgement produced by Eastman Teaching Films and one reel of a diacetate 35mm print at UCLA with the sequence of the President pardoning a young boy who is accused of being a deserter.

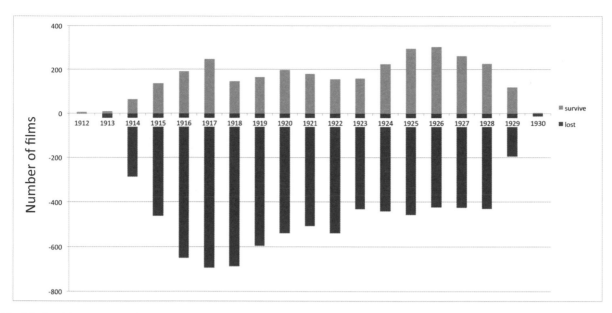

*Fig. 28: Surviving and Lost American Silent Feature Films, by Year*

You might expect that great films would survive. But what about merely good films? At the end of 1919, the *New York Times* chose 41 films as "This Year's Best." Nearly half of those titles survive: 12 in their 35mm domestic-release version, 5 in 35mm foreign-release versions, and another 2 in 16mm.[96]

These shortcomings can be partially balanced by an increased emphasis on providing wide public access to those films that do survive.

All this effort will be for naught unless the films are readily available for scholarship and public enjoyment. The greatest advocates for silent films were those who saw them on their first release—often in a huge downtown theater with a full orchestra—and found it difficult to explain the lessened impact of the films when seen in a small-gauge copy with a recorded piano score. That original audience has largely passed from the scene. Replacing those original fans is a resurgence of interest in and enthusiasm for films accompanied by live music, on DVD, and on the Turner Classic Movies cable channel.

While the academic interest can be met by high-quality streaming video over the Internet, these films come to life only when they are projected on the big screen. The focus of archives can shift from preservation to filling the gaps via targeted acquisition and a future of wide public availability.

---

[96] "The Year's Best," *New York Times*, January 11, 1920, VIII/3. The surviving titles in 35mm domestic-release version are *Blind Husbands, Broken Blossoms, The Crimson Gardenia, Daddy-Long-Legs, The Girl Who Stayed at Home, Male and Female, The Roaring Road, Shadows, True Heart Susie, Victory, Wagon Tracks,* and *When the Clouds Roll By.* Foreign versions survive for *Bill Henry, Scarlet Days, The Dragon Painter, The Life Line,* and *The Witness For The Defense.* Surviving in 16mm are *Deliverance* and the Kodascope release of *The Busher.*

# APPENDIX

## FIAF Archives Reporting Holdings of American Silent Feature Films

**The United States FIAF archives that reported holdings are:**

Academy Film Archive
George Eastman House
Harvard Film Archive
Library of Congress
Museum of Modern Art
Pacific Film Archive
UCLA Film & Television Archive
Wisconsin Center for Film and Theater
Research

**Other archives that submitted lists of their American silent feature films are:**

Archives du Film du CNC (France)
Arhiva Nationala de Filme (Romania)
BFI/National Film and Television Archive
(United Kingdom)
Bulgarska Nacionalna Filmoteka (Bulgaria)
Cinema Museum (United Kingdom)
Cinemateca Brasileira (Brazil)
Cinemateca do Museu de Arte Moderna
(Brazil)
Cinemateket-Svenska Filminstitutet (Sweden)
Cinémathèque Française (France)
Cinémathèque Québécoise (Canada)
Cinémathèque Royale de Belgique (Belgium)
Cinémathèque Suisse (Switzerland)
Cineteca del Friuli (Italy)
Cineteca Nazionale (Italy)
La Corse Et Le Cinéma (France)
Danish Film Institute (Denmark)
Deutsches Filminstitut-Dif (Germany)
EYE Film Instituut Nederland (Netherlands)
Filmarchiv Austria (Austria)
Filmoteka Narodowa (Poland)
Filmmuseum/Münchner Stadtmuseum
(Germany)
Gosfilmofond (Russia)
Jugoslovenska Kinoteka (Serbia)
Museo Nazionale Del Cinema (Italy)
Národní Filmovy Archiv (Czech Republic)
National Archives of Canada (Canada)
New Zealand Film Archive (New Zealand)
Oesterreichisches Filmmuseum (Austria)
Steven Spielberg Jewish Film Archive (Israel)

# Photo Credits

Fig. 2. Library of Congress, Prints and Photographs Division, reproduction number LC-DIG-ppmsca-06775.

Fig. 5. Photo courtesy of doctormacro.com.

Fig. 7. Photo courtesy of Media History Digital Library: www.mediahistoryproject.org.

Fig. 14. *The Americano* lantern slide courtesy of Matt Vogel.

Fig. 16. Advertisement courtesy of Rick Prelinger.

Fig. 17. Pathé. Photo courtesy of James Layton.